THE HANDBOOK OF
DIGITAL PHOTOGRAPHY

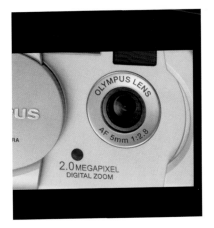

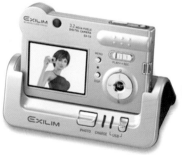

THE HANDBOOK OF
DIGITAL PHOTOGRAPHY

Published by SILVERDALE BOOKS
An imprint of Bookmart Ltd
Registered number 2372865
Trading as Bookmart Ltd
Blaby Road
Wigston
Leicester LE18 4SE

© 2004 D&S Books Ltd

D&S Books Ltd
Kerswell,
Parkham Ash, Bideford
Devon, England
EX39 5PR

e-mail us at:-
enquiries@d-sbooks.co.uk

This edition printed 2005

ISBN 1-856058-36-0

Book Code: DS0089. Digital Camera Handbook

Creative Director: Sarah King
Editor: Clare Haworth-Maden
Project editor: Judith Millidge
Designer: Axis Design Editions

Printed in China

Font used ITC Officina Sans

5 7 9 10 8 6 4

CONTENTS

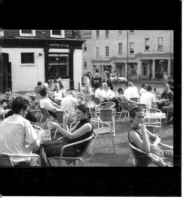

Digital photography is an ideal form of photography. You need never worry about whether to buy a fast or slow, black-and-white or colour or negative or positive film because you need never buy another film at all. You never have to wait for prints either, instead just taking a card out of the

Figure 1 A typical digicam, front view.

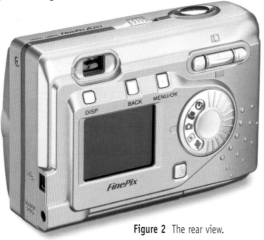

Figure 2 The rear view.

camera, pushing it into an inexpensive printer and then seeing your pictures emerge, sometimes only five minutes after you have taken them. The card is actually a memory store that enables equivalent effects (colour or black-and-white, for example) to be

achieved by making the appropriate changes, either within the camera itself or using the computer software that is handling the image, be it in your own or a photographic store's computer.

Figure 1 shows a typical or digital camera, or digicam. It looks like any other compact camera when viewed from the front, although perhaps a bit smaller than most. It measures 3¾ x 2¹/₂ x 1¹/₂ in. (98 x 64 x 40 mm), which is small, yet by no means the smallest digicam.

Now look at Figure 2, which shows the digicam's rear view. Apart from the presence of words like 'menu', the most obvious difference between the digicam and a film camera is the large, black rectangle. This is the screen, which, when in use, is illuminated and displays a picture, be it the photograph that has just been taken, a photograph that was taken previously or the view through the lens, which could be the next

photograph. The screen can also display the menu, which gives a list of the things that can be done, or have already been done, with the digicam. One of the major advantages of digital photography over film photography is that almost every digicam has one of these liquid-crystal display (LCD) screens (see pages 40–41 for more information).

Figure 3 When the camera's memory card is inserted into this Hewlett-Packard printer, the screen displays each photograph and the printer then prints 4 x 6 in. prints. There's no need for a computer. Some printers require you to plug in the entire camera, while others allow you to, edit pictures within the printer.

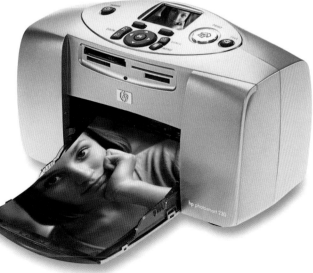

If you opt for using a home computer (and many digicam-users do, sooner or later), the process is both easy and easily learned. Camera and printer manufacturers are increasingly producing new designs that by-pass the computer, however, so that after you have docked the camera in the printer, you can programme the printer to make your desired changes before pressing the print button. But if you are reluctant to buy a printer, a photographic store will make the changes for you.

The advantages of digital photography

There is a whole raft of reasons why digital cameras are vastly superior to conventional cameras of every type.

- Their speed: you can look at a picture as soon as you have taken it.
- Their cheapness: you don't have to pay for any dud shots because you can just delete them. You don't have to pay for the good shots either because you can re-use the digicam's memory after downloading photographs (and some digicams require no memory at all).
- Their ease of use: you just point and shoot. You can, of course, do this with conventional cameras, too, but there are limits to what you can achieve with nineteenth-century technology. Digital systems' starting point is a clean sheet of paper, not the relative crudeness of a roll of celluloid that is coated with chemicals and stored in a cylinder.

Figure 4 Signing the register.

Figure 5 Leaving the church.

Digital photography is instant photography, something of which photographers have dreamed since the days when they had to use a horse and cart to carry all of the kit needed just to take a picture, let alone the equipment required to develop and print it in order to turn it into a viewable image.

The wedding snaps shown in figures 4 and 5 were taken with a digicam slim enough to be carried in the best man's pocket without disturbing the hang of his coat. They were e-mailed around the world at almost no cost, and on the very same day, to friends and relatives of the bride and groom who were unable to be present at the wedding. What a difference from seeing the proofs a few weeks later, ordering extra sets of prints and then having to pay the postage to mail them from Britain to Australia, where they would arrive perhaps six months after the wedding.

Not only do you never have to wait for the results of your photography to come back from the lab, but another tremendous advantage of the wonderful tool called a digicam is that you know

Figure 6 Old friends.
Take plenty of snapshots of your
family and friends to treasure in
the future.

immediately whether you have captured the image that you wanted and can take the picture again if you haven't. Nor will you find yourself having to waste the rest of the film because you want to have a few frames developed quickly.

Digital photography's immediacy has many further advantages, too. If you've taken a photograph of a bank robber being marched away by the police and want to sell the picture rights to the local newspaper, for example, you could show the photograph to the editor on the digicam's screen before even downloading or printing it. You could alternatively e-mail the editor a thumbnail (a small-sized copy) to

excite the paper's interest. Or maybe you're hosting a family reunion and would like to produce a print for each visitor to take home with them. If so, you could print it straight from the camera, without having to download the image (note that although not all digicams offer this facility, it is becoming increasingly available among new models).

Your digicam will take pictures that you can show on your television or project from your DVD player (that is, if you have a projector) to fill a wall of your living room, community centre or club. It will take pictures that you can print out at home to make into personalised Christmas cards, or can publish on your

Figure 7 A riverside picnic.

Figure 8 Memories of a summer evening: my university days.

website or an Internet group site for others to see, without having to pay for extra copies. And, of course, it will take snapshots that will remind you of happy days.

Every digicam can perform the functions discussed above, although not all of them will do so well. The choice of digicams is enormous, and growing rapidly every day, so much so that had I given any specific recommendations at the time of writing, they would have been out of date by the time that the book hit the shops. This book should nevertheless

help you to understand the camera specification that you will need if you are to achieve your aims, and will also introduce you to other digital-photography tools that you may want to put on your wish list to buy in future.

Although digital photography was invented during the 1960s, it took years for it to become available to ordinary people. Camera manufacturers probably started working on it seriously only when silver, the basis of conventional photography, was

becoming ever more expensive. Whatever the reason, it was not until the 1980s that digicams began to be used by serious professionals, especially those employed by big corporations. Today they are within the reach of nearly everyone, be they professionals, semi-professionals or amateurs.

The first amateur-level digicams had a reputation for producing poor-quality pictures, but this no longer holds true, and the current professional models are regarded as being the equals of the

Figure 9 Jessops' Fashion Cam, an example of a very basic digital camera that almost anyone can afford.

Figure 10 The PowerShot A300, a relatively inexpensive digicam that combines the quality for which Canon is known with a 5x zoom.

best conventional cameras (more than one professional photographer whose work is highly respected has gone on record as saying this). One professional, interviewed for the prestigious Royal Photographic Society (RPS) members' magazine, said that 3 x 2 ft (90 x 60 cm) prints are regularly churned out of a 6 megapixel digicam in his studio, and that they are at least equal in quality to those that were formerly made using professional, large- format cameras $2^{1}/_{4}$ in. (57 mm) square.

Digitising has completely revolutionised photography because excellent results are so simple to achieve, making good pictures no

longer the preserve of the professionals and experts, but available to everyone. Although you do need some expertise if you are to create some of the clever effects that it is possible to attain, it is an easy learning curve. In addition, unlike conventional photography, every mistake that you make doesn't mean yet another wasted, expensive film because you can just press 'delete' and try again, using the same camera, software and memory, and at no extra expense. This is why digital cameras have become a 'must-have' tool for amateurs and professionals alike – in fact, for anyone who agrees that one picture is worth a thousand words. Indeed, families really cannot do without a digicam, and proud parents

Figure 11 Estate agents now use digicams to take their own pictures of the houses that they are marketing. Not needing to pay a professional photographer saves the seller a lot of money, with the result that lots more photographs can be included in the property's particulars. It's also a far quicker process, and extra print runs do not incur extra costs. All that the estate agent needs to do is take the picture, save it and print it out when necessary.

Figure 12 You will need to take a lot of shots of a toddler before you get a good photograph, but if you have a digicam, you won't spend a fortune having all of those wasted shots developed. In fact, you won't have to spend anything at all on the dud shots because you can just re-use the digicam's 'film'.

should take lots of photographs of their children to print, e-mail and save to CD for posterity.

For those who are willing to try their hand at it, digital photography offers far more than its conventional counterpart, and without the need to invest in a darkroom and smelly chemicals or to waste materials on an expensive learning curve. Anyone can improve photographs using digital manipulation on a simple scale, and once you've gained in confidence you can do more and more if you want to. The subject of Figure 13 is a jug of

daffodils, a shot that was produced after only ten minutes of playing around with the image. You may not like blue daffodils, but it is a picture that hints at the possibilities that digital photography offers.

Shots taken straight from the camera are usually good enough for almost any purpose (the exception being, perhaps, the photographs entered into high-powered competitions, when a photograph must be 100 per cent perfect and 99 per cent isn't good enough), especially if the photographer has read this book and takes a little care. And anyway, a lot of image manipulation seems to be done to demonstrate the cleverness of the manipulator, not because it was necessary.

Although it is true that the latest digital cameras are fantastically complex, their complexity is masked by their remarkable ease of use, for a price

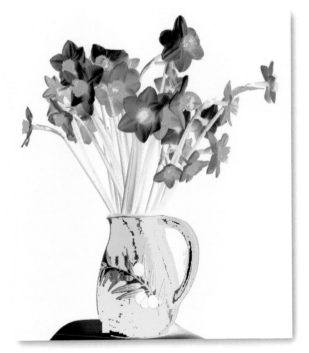

Figure 13 Software was used to manipulate this photograph of daffodils. The flowers' original colour was retained in their centres, but their outer petals were changed to blue.

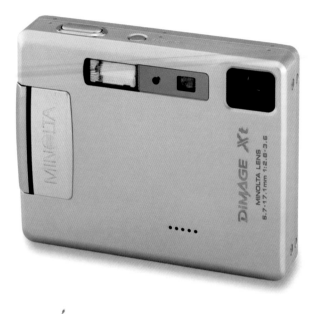

Figure 14 With 3 million pixels, the super-slim Minolta Dimage Xt digicam measures only $3^{1}/_{2}$ x $2^{1}/_{2}$ x $^{3}/_{4}$ in. (85 x 67 x 20 mm), the ideal size for a pocket or handbag.

that is staggeringly low, considering what you are getting. And, as a result of soaring sales, year after year they appear to be offering more for less money. It seems that everyone now has a digital camera, while some people have more than one, maybe keeping one in their car and one in their handbag or pocket, too. Sales of digicams have already overtaken those of conventional cameras. Don't be left behind!

chapter 1

ABOUT
PIXELS

ABOUT PIXELS

Pixels are always discussed in relation to digital cameras, the consensus being that a lot of pixels are required for a good photograph. It's important to realise, however, that no camera will perform well when working outside its capabilities, which is why you first need to understand what a camera's specification, especially its pixel count, tells you about its performance.

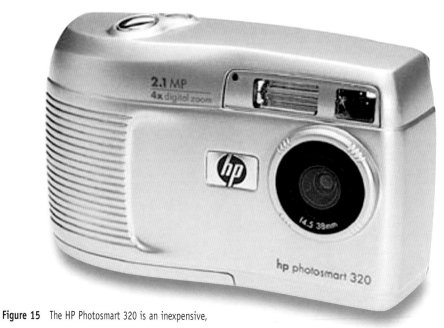

Figure 15 The HP Photosmart 320 is an inexpensive, 2.1 MP (megapixel) digital camera with a 4x zoom.

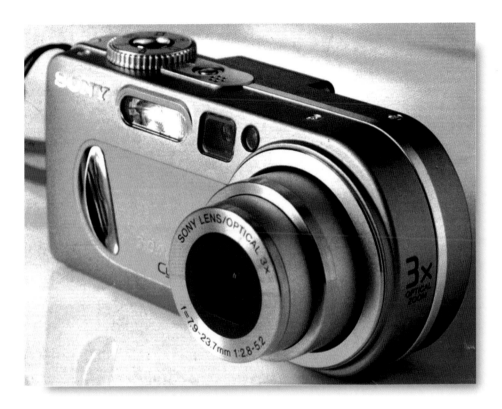

Figure 16 The Sony DSC P-10 digicam has 5 million pixels, an amazingly high number in relation to its small size, which is in the order of 4 x 2 x 1½ in. (10 x 5 x 4 cm) and relatively modest prize. Yet specifications are improving, and prices tumbling, all the time, so that by the time that the ink on these pages has dried, this camera will probably have been superceded by one that is both better and cheaper.

Figure 17 The Epson Stylus 1160 inkjet printer, which offers professional quality at an amateur's price – less, in fact, than the cost of anything but the cheapest digital camera. Epson is one of a number of companies that have made their names in other fields to move into the world of photography, using their digital expertise to produce cameras and associated photographic gear.

This book will not recommend any particular digicams because, with manufacturers announcing new digicams daily, such recommendations would be out of date by the time that you read this book. When you have some idea of what you want, I suggest that you study camera magazines' reviews and recommendations. Many of the journalists who work for camera magazines will have handled and tried a lot of cameras, and will have spotted problems that you would only have discovered months after making your purchase, which is why their advice is worth reading before making your short list and parting with your hard-earned money.

Note, too, that two cameras that appear alike on paper may handle differently, so that you may like one and not the other when you get your hands on them. For example, you may think that a camera that is small enough to tuck into your pocket is a good choice, but then would the buttons be too fiddly for your fingers? This is one of the reasons why it's a good idea to try out a camera before buying it. So when you think that you have narrowed your choice down to two digicams, it's worth handling both in a camera shop before leaving, mulling over your decision and then handling the models again in a different shop on another day before making up your mind and parting with your money.

It was, perhaps, the spread of the Internet, e-mail and personal websites, all of which call for quite low numbers of pixels in images, that launched the digital explosion. Users soon discovered that simple, easy cameras are just as good as the most complicated and expensive cameras for most Internet-related purposes, causing an explosion of interest in digital photography. The numbers of digicams sold in turn sparked an increasing interest among camera manufacturers in developing digital cameras. And when sales stopped climbing and instead really soared, manufacturers were able to spend even more money on research and development, consequently producing better and better models, with the Kodaks and

Canons of the photographic world also being provided with competition from new entrants into the camera-making field, namely the makers of other types of commercial digital equipment, such as printers, scanners and photocopiers, all of which have a lot in common. Indeed, because anything digital is concerned with generating, processing and storing a row of electrical signals (just like dots and dashes), the expertise gained in these areas can be

Figure 18 The Fuji FinePix S2 Pro, which produces 12 million pixels.

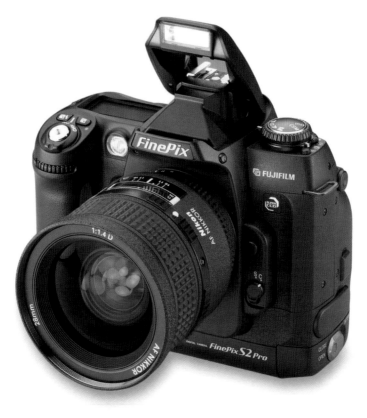

put to good use in digicam design, too.

Having read about the fast-improving world of digital photography, you may now be wondering whether you should hold off and wait for a while before buying a digital camera. Well, although you will probably get more pixels for your money if you do, you will miss out on a lot of fun while you wait. It may also be that this is a field in which the curve of progress won't level out for a long time, so that you'll just have to accept that if you buy the latest model tomorrow, it will not be the latest next week. Also consider this question: do you want to get into digital photography or are you simply hankering after a flashy new gadget or accessory? Either way, if you haven't already got a digicam, now is the time to buy one, be it because you will enjoy creating great photography or because you'll be ahead of the pack. The introduction of 2, 3, 4 and 5 million-pixel pocket digicams at affordable prices has already happened. They are here, in the shops, at prices that look ridiculously small by the standards of just a few years ago. They all offer enough for the needs of 99 per cent of users. So why wait for 10, 20, 30, or more, million-pixel cameras to be introduced at prices that suit your pocket? Do you actually want to be able to produce sharp prints the size of a bed sheet?

WHAT ARE PIXELS?

Now is the time to get to grips with pixels, to understand what they are and what they do. A digital image is made up of a series of tiny, square pieces positioned side by side in rows, with each piece being of a distinct and uniform colour (that is, the colour at one edge is exactly the same as the colour in the middle and at the other edge of the piece, but may be different to that of other pieces in the set). Each of these pieces is a pixel.

The information needed to generate each pixel's colour on a screen involves three separate factors: hue, saturation and brightness. Any colour can be created by mixing different amounts of three primary colours, and it does not matter much whether you work with red, green and blue, cyan, magenta and yellow or any other three-colour combination. Digicams usually work with red, green and blue (RGB), although professional printers of books and magazines generally work with cyan, yellow and magenta (CYMK – where the 'K' refers to the printer's plate used to add black) or more complex, four-colour systems. When working with digicams in RGB, we may start with the amount of red that is blended into a pixel. The system does not work in percentages, but in a series of parts ranging from 0 to 255, making the most red possible 255 parts, and the least 0 parts. The same is obviously true for green and blue. Mixing 255 parts of each together also creates black, while 0 parts of each makes white. If you count 0 as one of the possibilities in each case, the possible permutations are 256 x 256 x 256, which comes to over 16 million – rather more shades than on the average paint chart!

Figure 19 This Ricoh RDC300Z digicam, with its output of a mere 350 thousand pixels, is an old design, but remains in the company's product line-up, maybe because it is such a good little camera. Although it is outdated in many respects, it is perfectly satisfactory for e-mail and web pictures, unless you, and all of your correspondents, have broadband. Whatever speed your telephone company boasts about, remember that pictures often download at a rate of only 2 or 3 kilobytes (KBs) per second, so that it may take five minutes to download a picture that fills a computer screen, which is too long. The answer is to send a smaller file that only partly fills the screen, for which you do not need a multimegapixel camera.

Each single, tiny square, or pixel, in a photograph may be represented digitally by a series of numbers that represents its values. If you wrote down this enormously long string of numbers for each pixel, you would record the 'recipe' for generating that particular picture; another picture's 'recipe' would, of course, consist of different strings. (Some people find it mind-boggling that a digicam's tiny computer card contains all of this information.) If you therefore generate the right signals for all of the pixels in a picture, in the right order, bingo! You will have created, or recreated, the picture. This is how digital photography works.

The number of pixels included in a picture dictate its quality: the more and the smaller the pixels, the higher the picture's definition and vice versa, hence the importance of a digicam's number of pixels. When a digital camera is advertised, the number of pixels that it contains is therefore a key part of the sales pitch, especially if it is an impressive-sounding number, such as millions. 'What-to-buy' lists in camera magazines often group digicams by pixel number, and the impression that the buyer forms is that the more pixels a digicam has, the better. Yet camera manufacturers, who want to sell cameras with a high pixel count because they are expensive, tend to skirt over the fact that the number of pixels that you actually need, rather than the number you think that you might need, depends on what you want to do with a digicam.

Look at the range of digicams available, and it soon becomes plain that its number of pixels affects a camera's price. Although the cheapest digital cameras have less than 1 million (mega) pixels, you may be surprised by how useful they are for certain purposes: they are just as good as multimegapixel cameras for creating pictures to be e-mailed, for example. Yet 2 megapixel cameras are currently available for around double the cost, and they will perform far more functions. In summary, the cheaper the camera, the fewer the pixels, and the other way round, and although digital cameras seem to cost less every year,

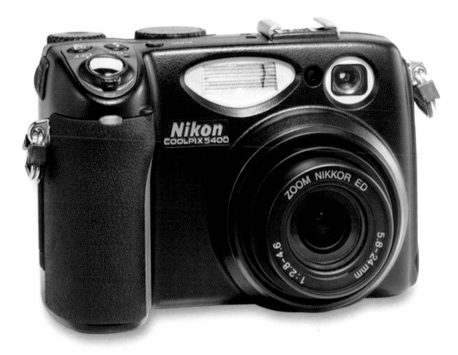

Figure 20 With its 5 megapixel output, the Nikon Coolpix 5400 provides professional quality in a near-compact camera. An interesting feature of this camera is the best-shot selector, which captures five different versions of a picture, but saves only the best, so that you do not rapidly fill up the digicam's memory with unwanted shots.

those with high numbers of pixels will always be the most expensive, and a few users may need them.

Another point to bear in mind is that manufacturers make cameras with higher pixel counts more complex, and that while some high megapixel cameras are easily managed, others can be a nightmare of knobs and switches, so that if any of these are set incorrectly, you may be disappointed by the results. By way of illustration, a businessman once bought the most expensive digital camera that he could find before going on a world cruise to celebrate his retirement. He was unable to take a single photograph during his trip, however, and thought that his camera was faulty, but never stayed anywhere long enough to find a dealer

to repair it. After the trip, he stormed back to the shop where he had bought the camera, only to be told that he had accidentally set a switch to preview-only mode, which meant that no picture could be taken. One second later, and the camera was shown to be working perfectly. There are three morals of this story. Firstly, you should always read a digicam's instructions; secondly, you should understand that the more complex the camera, the more skill and experience is needed to get the best results; and, thirdly, because the maximum number of pixels will come in a camera with a great many other features, you should ask yourself whether you want, or need, both them and a large number of pixels. This book aims to give you the answers.

WHAT DO PIXELS DO?

In the heart of every digital camera, in the place where a single frame of film would be if it were a conventional camera, lies the CCD (charge-coupled device), otherwise called the chip, sensor or array. The CCD consists of cells that receive the focused image from the lens and deliver it firstly to a buffer (a temporary store), and then to a processor, whose built-in circuitry turns it into a digital signal that is stored in the memory, ready to be

Figure 21 A Kodak EasyShare LS633, one of the first digicams designed to be easy to print from using a camera dock. At least half a dozen other camera manufacturers now offer this facility, which is rapidly becoming standard. If this feature appeals to you, do your homework and research the market.

recalled and reassembled into a picture, perhaps within a printer or computer. How this is done is very important because various cameras process the information in different ways that can affect speed and quality. This is such a complex issue that you will usually have to accept what camera manufacturers tell you, and they typically make two claims: firstly, that their method is different from any other company's; and, secondly, that their method is the best. Until you have a great deal of experience with digital cameras, the only other thing that you can do is read the reviews contained in camera magazines for advice.

The CCD consists of a large number of individual cells, each of which generates signals separately. The number of cells is usually approximately the same as the number of pixels advertised. Note, however, that the description 'effective' number or rating is used in two different ways. In the first, the effective number is quite close to the real number (the Ricoh shown in Figure 19, for instance,

has 350,000 pixels and its effective number is 330,000, the 20,000 not being used for the photograph instead carrying additional information with each picture). In the second, the effective rating may be 4 million, while the camera has only 2 million pixels. In this case, the camera is interpolating, or estimating, information scientifically, but is still only guessing what the image would look like if there were actually 4 million pixels. The results can be very good, but many experts think not as good as they would have been if the camera had actual, rather than effective, pixels. Usually, however, a 1 million-pixel camera has approximately 1 million cells, arranged regularly in a single layer in rows and columns. Each cell receives what, in non-scientific terms, could be called a 'spot' of light; in other words, the cell registers some (but not usually all) of the light falling on a particular point on the array, whether the light is dim or bright, red or green and so on.

Figure 22 The Nikon Coolpix 2100.

The number of cells in a row and the number of rows are usually in roughly the same proportion, similar to the proportions of the 35 mm-film frame, which measures 36 x 24 mm (about 1½ x 1 in.), so that there may be 1,634 pixels in a row and 1,222 rows, which, when multiplied together, make 1,996,748 (which is then rounded up to 2 million). Note that the sensor array does not actually measure 36 x 24 mm except in the case of one or two of the most expensive digicams. This point, which is explained on pages 111 to 112 under 'multiplier effect', will not concern you unless you buy a single-lens-reflex (SLR) digicam.

You may have noticed that the proportions of some pixel numbers are 4 to 3, not 3 to 2 (800 x 600, for example), but then the standard paper-print sizes have not been in strict proportion to film sizes since the days of plate cameras, and there is no reason why film should be either. Print sizes are not entirely logical, for 7 x 5 in. (175 x 125 mm) is slightly different in proportion to 6 x 4 in. (150 x 100 mm) and so on. These sizes owe more to the desire to cut up a large sheet of

paper with as little wastage as possible than to logic. The only issue to note is that if you take a film to a photo shop and order a range of enlargements in the various standard sizes, you will find that varying amounts of the photographs' edges are, or are not, included, in the different-sized prints. Returning to the pixels, if we were to use a microscope to look at four pixel cells positioned next to one another, two by two, perhaps at the corners of an imaginary square, one of the four will be arranged so as to be sensitive to red light; the one diagonally opposite will be sensitive to blue light; while the remaining two will be sensitive to green light. You may be wondering why there are twice as many cells that are sensitive to green light, and the answer is because the human eye is twice as sensitive to green and can detect more shades and variations in this colour than in either of the other two primary colours. More green in the 'recipe' simply means better colour rendition, for this reason. It may seem miraculous that the signals, of different levels of intensity, emitted by those cells can create a picture on the screen or page.

Figure 23 Some pictures have length and height in different ratios than the 5 x 4 or 3 x 2 formats.

Why are only three colours used? Because, in practice, different amounts and intensities of these three colours can be reconstituted into any colour. To illustrate further, a computer screen is usually set to produce a minimum of 256 colours using so-called '8-bit technology' because different combinations of 8 binary bits can give 256 different combinations, each of which can be linked to a different colour. Twelve-bit technology can produce a few thousand colour permutations, 16-bit technology can result in millions and so on, but note that each higher level takes longer to process and needs more random-access memory (RAM) space. You probably could not tell the difference between the use of higher and lower numbers or

Figure 24 This photograph contains many shades of green.

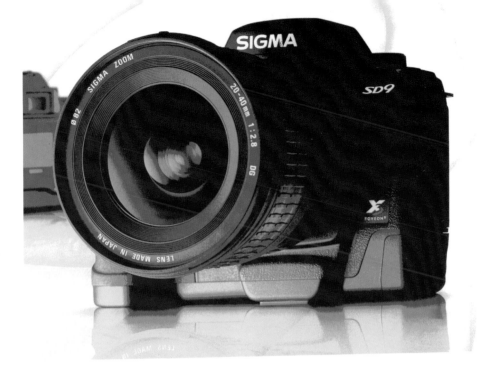

Figure 25 In this Sigma SD9 digital camera, separate red, green and blue signals are taken at different layers on each cell, in much the same way that a conventional film works in three layers to record one colour on each layer.

bits on a computer screen, but in the finest colour printing – in an art book, for instance – the higher numbers give a more subtle 'feel' to a picture, a difference that, although hard to define, is easy to see, which is why they are used in the most expensive forms of printing. Even higher numbers, such as 48-bit technology, can be used, and, in summary, the higher the bit number, the more complex, and therefore potentially the better, the picture.

Digital technology is still developing, and new inventions are being pioneered that may make a more subtle rendering of colours possible from a smaller number of pixels, or a better colour rendering from the same

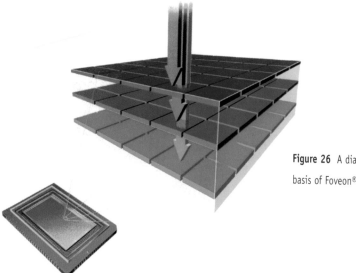

Figure 26 A diagram illustrating the basis of Foveon® technology.

number. One such is Foveon® technology, which was first used in the 3.4 million pixel Sigma SD9 shown in Figure 25. Whether users think the results produced by Foveon® are as good as those produced by a more conventional, 10 million-pixel camera remains to be seen, for at present not many of these cameras are in use. But logic suggests that 3.4 million pixels used in this way will be equivalent to over 10 million pixels in a conventional digicam because each pixel is giving three signals, making this another illustration of a case in which a camera's pixel number is not quite as meaningful as one may initially think.

Another new development is the double-honeycomb chip used in the Fujifilm FinePix F700. Fujifilm offers two virtually identical cameras, one of which is the F410, which uses a single (conventional) 3.1 million-pixel chip, while the others use the double honeycomb, that is, a 6-megapixel chip. The single version uses interpolation, scientific terminology for using guesswork to add results to those obtained by the pixels themselves,

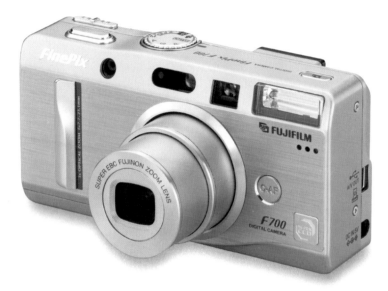

Figure 27 A front view of the Fujifilm FinePix F700, showing the lens extended, as it is in use.

whereas the 6 megapixel chip takes that number of readings. The surprising conclusion to emerge from early reviews is how good the 3.1 million-pixel camera performs for much of the time, although presumably the 6 million pixel camera must have the edge.

Interpolation is used by several manufacturers. When reading a digicam's specifications, look for the words 'effective pixels' and see what is then said about 'actual' pixels. If the figure given for 'actual' is only half that of the 'effective' pixels, interpolation is used, providing that

number of signals. Reviewers often think that the results produced by an 'effective' 2 megapixel camera are inferior to those produced by a genuinely 2 megapixel camera, which is not a surprising conclusion to reach. Such developments indicate the kind of work that is being carried out behind the scenes as a large number of companies fight it out for their market share and reputation. Who will be the market leader in five years time? Who knows!

SCREENS ARE FOR VIEWING

SCREENS
ARE FOR
VIEWING

Figure 28 shows the LCD screen in use on a very small camera, which nevertheless offers 4 megapixels. Its compact dimensions will hardly make your pocket bulge, but the digicam consequently has only a small screen, measuring a mere 25 x 15 mm (1 x ⅝ in.), although it is still clear enough for you to see the picture. Screens measuring 38 mm (1.6 in.) or 45 mm (1.8 in.) are more common, and a few digicams have screens measuring more than 50 mm (2 in.).

Figure 28 The rear view of Kyocera Finecam S4, a 4 megapixel, pocket-sized camera measuring only a little more than 10 x 5 x 2.5 cm (4 x 2 x 1 inches).

The word 'pixel' is a combination of the abbreviated words 'pictures' ('pix') and 'element' ('el'), for each pixel is one of the elements of a picture, specifically the smallest element into which a photograph can be divided. Pixels have significance not only within the camera, but, should an image be downloaded for viewing or manipulation, also on the screen.

Almost all digital cameras have their own screen, or liquid-crystal display (LCD). Sometimes, albeit rarely, the LCD is used for composing the image, in a way that is quite common in digital videocams, rather than using an eyepiece viewfinder as in conventional film cameras. However, in most digicams (including single-lens-reflex (SLR) types, in which the eye looks through a viewfinder that in turn looks through the lens to see the image almost exactly as it will be recorded, as well as other digicams that have a conventional optical viewfinder), the LCD is most often used to check the image, ideally before you leave the scene, so that you can take another shot if necessary. The LCD is also used to look through images – sometimes in conjunction with a built-in editing software programme within the camera – in order to name, delete or save individual frames. A few cameras also allow you to resize, crop or otherwise adjust pictures. (See also pages 96–97.)

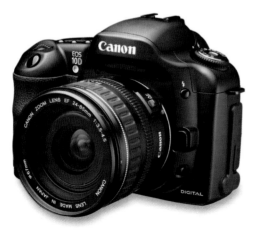

Figure 30 The Canon EOS 10D, with its 6.3 megapixel sensor, is near the top end of the digicam market, and not only in terms of its versatility, quality and price. As an SLR it has only a small LCD screen.

Figure 29 This photograph shows the LCD of a Sony Cyber-shot digicam, with the camera turned sideways. The LCD displays a picture taken in the garden, along with additional information, a feature that can be turned on or off by pressing a single button.

Switch off the LCD for picture-taking as it prolongs the digicam's battery life. LCDs burn up a lot of electrical current, and if you have a digicam running off a set of AA batteries and the LCD is always on, you will find the camera costly to run because you'll need to change the batteries so often. Alternatively, you could use rechargeable batteries, which are more expensive than ordinary alkaline batteries, but being able to recharge them, rather than having to buy new ones, will save you save money, and they also will run for far longer than alkaline batteries before going flat.

Figure 31 A rechargeable Li-On battery and battery-charger, which enables the battery to be charged up while the camera is being used with a spare battery.

When purchasing a digital camera, it's important either to consult the dealer or to read its instruction book before buying any spare batteries, however, because the makers of some digicams often recommend specific types of battery and warn against using others.

The LCD uses pixels, but usually far fewer than those used for recording pictures. And when choosing a digicam, you needn't worry about the number of pixels used for the LCD, as long as the image looks bright and clear. (You may, however, be interested to know that the camera shown in Figure 32 has 2 million pixels allocated to the picture, but only 100,000 to the LCD.) The picture displayed on the LCD will, of course, be smaller than the image is likely to be when it is printed out or viewed, but remember that the purpose of the LCD is not to enable you to check a picture's quality, but merely to show you how it looks. And you will see immediately that a picture taken with many pixels has to be converted to be shown by far less on the LCD. Although the same kind of operation is possible in reverse, this does not mean that 500,000 pixels can do the work of 5 million.

Figure 32 A view of the top of the Minolta Dimage F300, showing most of the controls and the display screen, which gives technical information about the settings in use, including auto flash (one of the various flash options), the picture quality, file size, battery state and number of pictures that have already been taken. The wheel allows different settings and controls to be accessed in a simple manner.

COMPUTER MONITORS

Now let us consider a computer screen, or, more correctly, a monitor screen, whose pixel count can be important when it is used for handling digital pictures. If you have a computer, how do you discover how many pixels are on your monitor screen? If you are using a PC and Windows XP, first go to 'Start' and then select 'Control Panel' from the pop-up menu (see Figure 33). (Mac users should check their Monitors Control Panel, or in OSX, the System Preferences and Display tabs.) Double-click on 'Display' to get the 'Display Properties' window (see Figure 34). Now select the 'Settings' tab (see Figure 35). Figure 35 shows that this screen setting (which can be reset by dragging the pointer to the right) is 800 x 600 pixels, which is sometimes called the SVGA setting (as, rather confusingly, is also a setting of 1,024 x 768 pixels). (The abbreviation 'SVGA'

stands for 'super video graphics array', a term that has more significance for digital projectors, which are often advertised as 'supporting SVGA'.) Another common setting is 640 x 480 pixels, a VGA (video graphics array) setting, and there are also higher numbers with different values, for example, XGA (extra graphics array).

By following the above steps, you can set the pixels on your monitor screen to as high a number as the PC's processor will handle, thereby giving you the best definition. But note that it is no use trying to set the pixels to a higher number than your equipment is able to deal with. It is important to remember that this setting (800 x 600 pixels, for example) will be the one that you should enter under 'image size' when adjusting a picture to fill the monitor screen, perhaps when

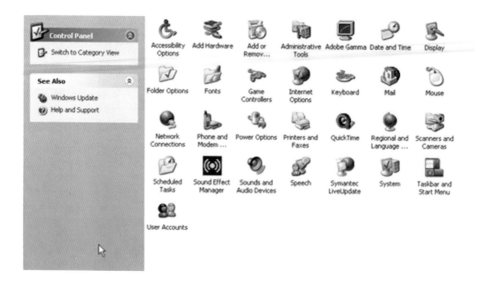

Figure 33 The 'Control Panel', selected from the 'Start' menu in Windows XP.

preparing to stage a slide show or to project an image onto a screen. If you enter another setting, you will be making unnecessary work for the processor and the pictures will take a long time to load when slides are being changed.

Now either literally take a picture with a low pixel-count setting or imagine taking one. You can take such a picture with a high pixel-count camera if you know how to adjust file sizes, or if your camera's maximum pixel count is in any case low, which will usually be the case if the camera predates 1999, such as the Ricoh shown in Figure 19, which has a VGA 640 x 480 recording element (and 640 x 480 = 307,200 pixels). If this picture is shown on a monitor screen that is set to the same value (640 x 480, for instance) VGA, then each of its pixels will correspond to one on the monitor screen. In addition, the picture in the camera will be the same shape and size as that on

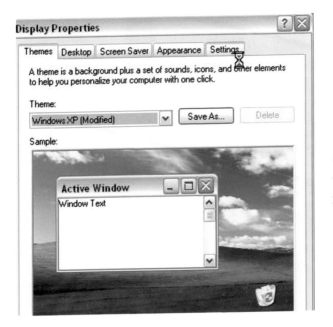

Figure 34 The 'Display Properties' window, accessed from Windows XP's 'Control Panel'.

Figure 35 Clicking the 'Settings' tab of the 'Display Properties' window enables you to select the colour setting via the drop-down menu just above the rainbow-coloured strip. Note that this monitor screen is set to 32 bits.

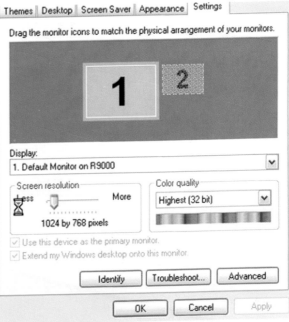

Figure 36 You can stage a slide show on both a laptop and desktop computer's monitor screen, as well as on a television screen.

the monitor screen, although the pixel number of the picture in the camera is real, whereas the monitor screen produces a comparable result using different terms. If you experiment to see what your monitor screen looks like at two different settings, the numbers and icons will look smaller at the higher setting, but you won't see any extra information, in the same way as a large television screen doesn't show a newscaster's legs when a smaller screen shows only the head and shoulders. What happens if you show a 300,000-pixel picture on a monitor screen set at 750,000 pixels (that is, if you show a

Figure 37 A picture whose pixel count has been resized downwardly to give a pixel-width setting of 1,048 on the screen.

Figure 38 A picture whose pixel count has been resized upwardly. Originally occupying a pixel width of only 600, it was then enlarged to make it seem the same size as the picture in Figure 37.

VGA picture on a SGVA screen)? Either of two things: firstly, the picture will occupy only a small, 300,000-pixel section of the monitor screen; or, secondly, the wizardry of any software designed for the purpose within your computer will automatically make adjustments so that the picture fills the monitor screen. The same kind of handling system can even enable pictures with larger pixel numbers (6 million pixels, for example) to be seen on a smaller pixel-count monitor screen. Suitable software can therefore expand small pictures to fill large screens and vice versa. But does your computer's ability to make up a picture mean that your digicam does not need a lot of pixels? Well, no, it doesn't, because a small picture that has been enlarged to fill a big monitor screen will suffer in terms of quality.

Look now at figures 37 and 38 on page 47). If the picture in Figure 38 had been left its original, smaller size, it would have looked just as sharp as the photograph in Figure 37. Enlarged, however, and each pixel is having to do too much work. The more pixels that are used to take a picture, the better it will look when enlarged. But if you enlarge it too much, you will see pixelation, or the little squares of colour that make up the image, which doesn't form a satisfactory picture.

AVOIDING
PIXELATION

The first important lesson to be learned from the information given above is that you do not need a 6 million-pixel digicam if all you want from it is standard-sized snaps of your family to carry in your handbag or briefcase. In addition, pictures taken by a digicam

Figure 39 A photograph in the process of being trimmed in size in Photoshop. The brighter area is the required part, and the darker area will be discarded; only half of the picture area, and hence file size, is being retained. If you need a 2 megapixel image with which to produce a good print at the required size, you will have to start with a 4 megapixel image.

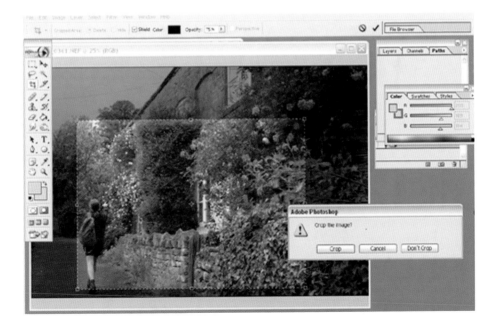

with a relatively modest pixel count will look quite good on a computer's monitor screen for a slide show, and not that many more pixels are needed for a picture show screened on a television. Remember that a small television is watched from a close distance, and a large television from a greater distance, but the appearance of the image is the same because the number of lines is the same on a television screen measuring 32 in. as it is on one measuring 14 inches.

But standard-sized pictures probably won't keep you happy for long: sooner or later someone will, no doubt, want a larger picture to frame. And frames are usually sold to take standard print sizes, especially the postcard-sized 3 x 5^1/$_2$ in. (75 x 140 mm) or 4 x 6 in (100 x 150 mm). So here is a rough guide to the camera specification needed for enlarging pictures successfully, ranging from 1 to 4 mexapixels:

• a digicam with 1 megapixels will produce good prints measuring up to 5 x 7 in (125 x 180 mm), and will also create good-quality images (even if of a fraction of that size) for e-mailing or posting on websites;
• a digicam with 2 megapixels will produce satisfactory prints measuring up to 10 x 8 in. (254 x 203 mm);
• a digicam with 3 megapixels will produce good prints measuring up to A4 size (8 x 11^1/$_2$ in. or 210 x 297 mm), including 10 x 8 in. (254 x 203 mm) prints;
• a digicam with 4 megapixels will produce good-quality 20 x 16 in. (508 x 406 mm) prints, which will probably only interest keen club photographers who require large prints for exhibitions.

Remember that talk of a so-many-pixel camera being good for such-and-such-sized prints is based on all of the image being used. If you only want a 5 x 7 in. (127 x 178 mm) portion taken from half of a picture, you will therefore still need a camera that is

capable of producing 10 x 8 in. (254 x 203 mm) prints. Indeed, you will rarely use the whole frame, even if you want to enlarge a photograph to hang on the wall, and a digicam with 4 megapixels will give you the largest image that you are ever likely to need, whether you use all of the original picture or not, which is more than can be said for digicams with smaller pixel counts.

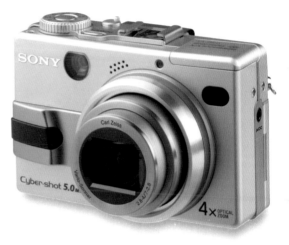

Figure 40 Sony Cyber-shot digicams have won a high reputation. This one has 5 megapixels and a 4x optical zoom.

Cameras with 5 and more megapixels (6 million is currently about the largest number in cameras for amateurs), and arguably some with slightly fewer pixels, will make 30 x 20 in. (762 x 508 mm) prints, but a printer capable of handling A3-sized (about 11^1/$_2$ x 16^1/$_2$ in., or 297 x 420 mm) paper is even rarer than a 6 megapixel digicam, and costs perhaps twice as much as a good-quality, A4-sized printer, which is in turn rather more expensive than a more basic A4 photo-printer. And the only printer capable of producing a print measuring 30 x 24 in. (762 x 61 mm) is a commercial roll-printer. That having been said, there are still good reasons for buying these cameras (after all, if you want a giant print, you can always have it made by a photographic shop), not least their extra features.

One of the reasons why these high-megapixel cameras are manufactured is that they can produce the high-quality illustrations demanded by publishers of books, technical works and so on, particularly when the original image is much larger than the one that is published. Because they often have extra, specialist facilities, they are also

Figure 41 A 6 megapixel shot saved in RAW format and converted for this illustration. Its quality is much better than necessary, but it was taken and saved in this size in case it came in useful in the future.

Figure 42 A Nikon training course being held in a dimly-lit lecture room that doubles as a graphics studio.

more complex, which may not appeal to you, even if you can afford such a camera. Remember that if a digicam has dozens of knobs to twiddle and switches to set, there is a risk that you will set at least one wrongly, while you cannot go wrong with a point-and-shoot digicam. If you are determined to spend a huge amount of money on a camera like this, however, it is well worth spending a little more on attending a course run by the camera's manufacturer.

RESOLUTION, PICTURE QUALITY AND FILM EQUIVALENTS

RESOLUTION, AND PICTURE QUALITY

Another factor that complicates the issue of pixel count is resolution, which influences how sharp a picture looks.

Computers' monitor screens are normally set to a resolution of less than 100 dots per inch (dpi), the exact figure depending on the operating system employed, a spacing at which colour signals are generated. The pixels across the screen occupy the same width as, say, 72 multiplied by the effective screen measurement in inches. For example, a flat, 15 in monitor screen effectively measures 12 in horizontally because it is the diagonal measurement that is quoted as being 15 in. Such a screen therefore actually shows 72 x 12 = 864, or 96 x 12 = 1,152, dots of light (or dark) across the width of the screen, and each of the digicam's pixels in each row has to supply a signal for rather more than

one dot, whatever setting has been chosen for the screen. So translating the image to the screen almost always requires some adjustment within the computer, and is not simply a matter of one camera pixel equalling one screen pixel.

In practice, the greatest problems with quality can occur when a picture is viewed in print form, especially when a high-quality image is required, such as for an art or coffee-table book or periodical. In general, home colour printing is done at a resolution much less than 300 dpi, while high-quality, professional printing work is often done at a much higher figure: 1,200 or 1,600 dpi, for instance.

Scanners frequently work at very high resolutions, but note that because the scanned image is initially sent to the

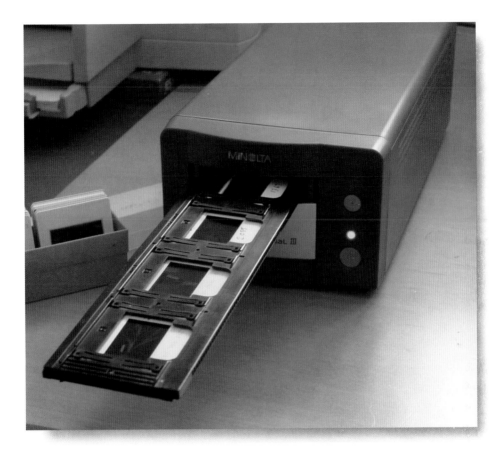

Figure 43 The Minolta Dimage Scan Dual III is a dedicated scanner for 35 mm film strips and slides – an APS ('automatic photo system') adaptor is available – that scans at 2,820 dpi, ample resolution for almost any amateur purpose. Its carrier is shown holding four slides, which can be scanned in succession.

computer's RAM (random-access memory), 128 mb of memory may not be enough. If you want to scan multiple images at a resolution above 300 dpi, especially if you have a scanner that scans many slides in one pass before you are given an opportunity to save them from RAM to

your hard disc, you will therefore probably have to install additional memory. The scanner illustrated in Figure 43 works mostly in 8 bit mode, and sometimes in 12 bit, but more sophisticated scanners, such as the Dimage Scan Elite II (which works at the same dpi resolution) work in higher modes, in this instance 16 bit, for which 1 gigabyte (GB) of RAM is recommended (and you will still need to ensure that quite a large portion of memory is allocated to this purpose).

When printing an image from a digicam using a high-dpi resolution, each of the digicam's pixels supplies signals that control a large number of dots

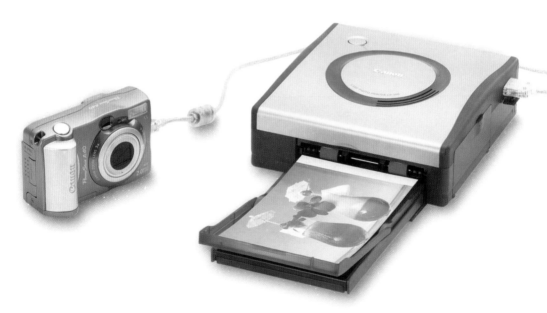

Figure 44 The Canon CP100 printer. In this and other simple printers, one ink cartridge supplies all of the colours. You will therefore have to throw the cartridge away when you have used up one colour, even though it may still contain useful amounts of the others.

(individual spots of ink that are so minute that the naked eye cannot discern them). If each digicam pixel has to give instructions to too many dots, the picture quality suffers, so that a digicam with a low pixel count will produce an image that isn't very sharp, or, worse still, that is blobby and totally unsatisfactory. This is why you must have a camera with a high pixel count if you are taking pictures for publication in print, but then digicams with 3 megapixels (which is ample for many professional purposes) are becoming increasingly common. Perhaps surprisingly, much lower, computer-set pixel counts can be used for images that are intended to be projected and enlarged to fill a wall-sized screen, for example (see pages 220–221).

Each dot of ink that a home printer produces will usually consist of one of three colours, which, in combination, make up a range of shades. The more complex printers contain three separate colour cartridges – perhaps magenta, yellow and cyan – which can sometimes be replaced individually. Even more sophisticated printers (some of which are relatively inexpensive) use six or seven different colours, while a few of the better quality photo-printers can be converted to continuous-inking systems, although you would need to print a huge number of prints to justify the cost of buying one of these.

A ROUND-UP OF PIXEL NEEDS FOR YOUR PURPOSES

The resolution issue is an additional complication that should be taken into account when trying to decide how many pixels your digital camera should have. To help you to make your decision, you'll find it helpful to list the things that you want to do with a digicam, along with the number of pixels needed for those tasks, as outlined below.

E-mailing pictures

When e-mailing pictures, the time that it takes to up- and download them is of the utmost significance. A large picture means a large file, which will take some time to move along a telephone line. It can take many minutes to download a 2 megabyte (MB) file when using an ordinary telephone line, for instance, whose typical image-transfer rate is 2 or 3 kilobytes (KB) per second. The process is faster if you have broadband, but if the receiver doesn't, he or she won't necessarily thank you for e-mailing a picture that takes fifteen minutes to download. Before e-mailing a picture, a good rule of thumb is therefore to compress it to a size that is less than 100 KB in the JPEG (or JPG) format, which equates to roughly 300 x 200 pixels.

Posting pictures on websites

The advice given above for e-mailing pictures also applies if you are posting pictures on a personal or shared website, such as a discussion group's. The general rule for preparing all pictures that will be viewed on a monitor screen is to try to keep the pixel count down to about a quarter or third of the screen's width (you could always mention that a larger picture file can be e-mailed on request).

a snap of my new spider orchid

File Edit View Tools Message Help

Reply Reply All Forward Print Delete Previous Next Addresses

🔋 OE removed access to the following unsafe attachments in your mail: e-mailable brassia.jpg

From: geoffrey hands
Date: 11 June 2003 15:21
To: Vincent Lowe
Subject: a snap of my new spider orchid

Dear all,herewith a snap of the plant I was telling you about:-

Regards
Geoff

start 📷 SnagIt Adobe Ph... W 2. Micros... My word ... Nikon Bro... Outlo...

Figure 45 This monitor screen shows an e-mail with an opened picture attachment (before being opened, the file appeared as an icon). The original file, which contained under 12 million pixels, was reduced in size to about 50 KB. Because e-mailed pictures will be viewed on a monitor screen (and won't fill the entire screen), they do not require a huge number of pixels.

My greenhouses - how I grow my orchids

return to home page

1 The plant house. To see apicture of it looking good, with lots of flowers, click here. This is a 25ft long and 15 ft wide Hartley Botanic house on a dwarf wall. The individual panes of glass are 5ft long (clear toughened glass) and the light inside the house is the best I have ever seen which I think is due to the near semi-circular shape and the ridge running practically due north-south meaning that in daylight there is always one row of panes at a very advantageous angle for light transmission - in a conventional upside-down Vee shaped house the panes are all at the best position for a short while and all at the worst position for a short while and somewhere in between for the rest of the time. Automatic ventilators set to open at 15 (60).., Heating set to 13 (55). Humidification by a hydrofogger on a time clock - at dawn it is foggy inside, just like a real cloud forest.

Currently used for Cymbidiums, Miltoniopsis, Vandas, Cattleyas and some dendrobiums - the high light orchids.

1. 2. 3.

1 shows how the greenhouse is part-hidden on the west side by one of the garden borders.

2. is a closer view of the north end from which various shade devices can be just seen.

3 shows the interior. Note the 1.5metre sweep fans, and the interior inverted Vee shaped blinds made of the Svensson solar reflecting material (aluminium foil strips spaced apart by their own width on a polypropylene scrim of notional 50% shade value. But lower angle sunlight comes in below them - and here in UK the sun is only high in the sky in the summer and in mid-day. So The shade value is high when I want it, and of very little practical effect when I don't - ideal The centre bench is Cymbidiums in rock-wool watered by individual pipes with dripper nozzles fed by a timer system controlled pump from an under-bench tank. The blinds were/are motorised - at one time I had the intention of automating them via a light sensor, but after spending much labour on the (home-made) system I decided it was not going to be reliable enough, and anyway is not needed for the reason set out.

456

4. Shows a bench of tip bearing hard-caned dendrobiums (D. section Phalaenanthe) newly brought home from Thailand- I will try and snap them, and show them, whilst they are still good. I put them in hydroponics in pebbles, and they picked up after their days in the plane hold , remarkably.

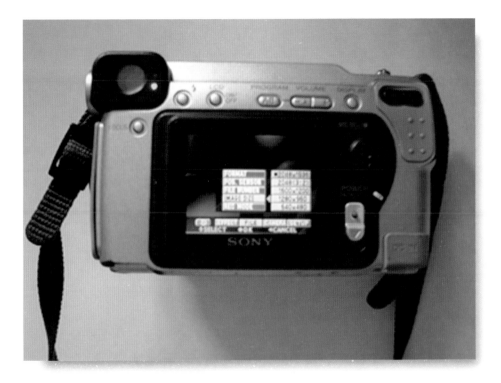

Figure 46 Here is a sample of a typical personal-website page. The text, which was composed in a word-processing programme, is illustrated with a series of pictures little larger than thumbnails. The picture files are quite tiny in size – maybe less than 20 KB after compression – to enable the page to be downloaded quickly, even by a viewer with a slow telephone connection. Although the pictures have been reduced in size to save viewers time and money, the quality of the images remains acceptable.

Figure 47 A Sony Cyber-shot digital camera in the process of being reset. The menu is accessed by pressing the main control button (situated diagonally above, and to the right of, the LCD), the same button being used to scroll through the menu, and then the sub-menus, selecting, confirming and so on. It is a quick operation that soon becomes instinctive.

Do not forget that some people will be viewing your pictures on monitor screens that have been set to lower pixel numbers than your own, so if you regularly post pictures on a shared website, you may find it convenient to optimise your screen at a lower setting.

Making prints

If you want to produce prints, choose a digicam with as many pixels as you think you will need (see pages 50 to 52), which will almost certainly be enough to enable it to perform any other function, too (most other usages call for less quality). Note, however, that if you intend to do more than just point and shoot, you will need a digicam with a relatively large pixel array.

You can set a camera with a larger-sized pixel array to produce both small and large files (after which your computer can do the work of reducing the size if necessary). Setting your camera to a lower file size will enable you to squeeze more pictures onto the memory card – or to buy a smaller one

– before having to download them, but if you select this option and change your mind about what you are going to do with a picture, you may regret not having taken it in a larger format. This is why some digicam-users keep their cameras set to a large file size. A 3 megapixel digicam can be set to produce images in five different file sizes, ranging from 2,048 x 1,536 pixels = 3.14 million pixels to 640 x 980 = 627,000 pixels. As long as you do not want to use only a fraction of an image, this camera will probably be able to produce any print you want, especially if you work in the largest of these sizes.

Staging slide shows

If you want to stage slide shows (when the pictures are viewed one after the other, see audio-visual presentations, or AVs, pages 210 to 224) on a computer's monitor screen, the camera needs to be capable of producing screen-sized pictures and should have a maximum pixel count equal to the monitor screen's setting. This means that if your setting is SVGA, you will require a 1 million-pixel file (1,024 x

Figure 48 Viewing an A3-sized (about $11^{1}/_{2}$ x $16^{1}/_{2}$ in, or 297 x 420 mm) print created from shot taken with a 3 megapixel camera.

768 = $^{3}/_{4}$ million pixels). Because a good rule of thumb is to double the pixels required to give yourself room for manoeuvre (quite apart from any cropping or trimming that may be necessary), it may be best to buy a 2 or 3 million-pixel camera.

You can also present slide shows on a television screen, when the same advice applies, although note that larger files that have been reduced in size will give better results. Remember that you can ask your camera shop to download your images onto a CD to

Figure 49 An image projected onto a 4 ft² (1.2 m²) screen. Digital projectors can easily project even larger images.

insert into a DVD player and show on the television screen.

A slide show may also be presented on a big screen, using a projector. A higher-quality image is required for this purpose, which you should then, using computer software, reduce to a suitable pixel count and compress to produce a file that is quickly handled by the computer's processor. A camera with 3 million pixels is a suitable size in this instance.

FILM
EQUIVALENTS

Before deciding which digicam to buy, there are further important aspects to take into account and understand. How many pictures can you take before having to download the images, for example, and how can you expand on that number? The answers to these questions depend on the amount of memory provided with the camera.

In digital photography, memory means image storage, and is the equivalent of film in conventional photography. Film is available in several types and sizes: black-and-white films, colour-print films or colour transparencies (technically, colour-negative or colour-positive transparencies) and rolls containing 24 or 36 frames, for example. The advantage of a digicam is that it contains only one kind of digital memory, which means that if you need a faster speed, for instance,

you don't have to take out the film and waste the rest of the roll, as you often do in conventional photography. You can easily turn a digicam's colour picture into a black-and-white, sepia-toned or grainy image, for example, either by changing the camera's setting or by using computer software.

Conventional film is sold in a range of speeds and sensitivities, too, while a digicam's memory offers only one speed, although some digicams enable different sensitivities to be used just by changing a camera setting (unlike in conventional photography, when you have to change films, in the process sometimes wasting many frames). Film speed is quoted as an ISO ('international standards organisation') number, and each doubling of the number indicates a doubling of the film's sensitivity or speed. The same

Figure 50 Although a colourful scene may not be the best subject to convert into a monochrome picture, it can be done with the flick of a switch (see Figure 51).

Figure 51 A digicam's capacity to convert a colour photograph into a black-and-white image can be useful if you want to enter a photograph that was taken in colour into a photographic competition's black-and-white category.

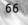

Figure 52 A Kyocera Finecam's sensitivity in the process of being reset. To do this, you need to turn a selector switch to the correct position, press 'menu' and then use the bright buttons to scroll through the menu until you have found, selected and confirmed the desired setting on the LCD. (You'd be well advised to keep the instruction book to hand until processes like these have become second nature.)

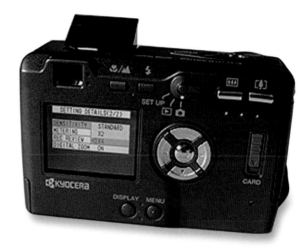

figures are used for digicam sensitivity and usually range from 50 upwards, although many digicams which are adjustable (and many are not) only provide 100, 200 and 400, for example. The more complicated, single-lens-reflex (SLR) cameras provide the best range. You probably won't need to use this facility very often, but when you do, you'll find gaining an extra stop (see page 128 onwards, and Chapter 8, pages 165–169) or more a godsend (you'll have to pay the price in terms of quality, however, so make sure that you use the largest-possible file size

when using faster-sensitivity settings).

To understand sensitivity, you need to appreciate that film speed is one of three factors with which a camera juggles when it is running on automatic, or that you can select to influence the camera to use the right exposure. Extra sensitivity is required, for example, if the shutter speed is too slow, despite the lens having been opened to its maximum. Similarly, if your camera refuses to take a shot, telling you 'light too low' or 'use flash', but you cannot use the flash, perhaps

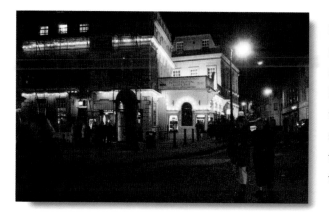

Figure 53 A street scene photographed at night, in the only available light, and, as the lack of blurriness caused by movement indicates, without using a very slow shutter speed. Conditions like this require a digicam's sensitivity to be set to high.

because the subject is too far away or you do not wish to draw attention to your presence, choosing a higher sensitivity may enable you to take the picture.

In conventional photography, a photographer needs to know how to juggle the film speed, shutter speed

and lens aperture (see also Chapter 7) in order to take a good photograph, or else relies on a film's DX code automatically to adjust the speed setting to the correct ISO rating. In digital photography, it is, perhaps, simpler still: you leave the setting on minimum until the digicam gives you a warning, whereupon you raise the

Figure 54 A Nikon D-series camera. ISO has been selected on the function dial on the left, while the specific setting was selected by turning one of the command dials on the right. 1600 ISO has been selected here, but two higher settings are also available: 3200 and 6400 ISO.

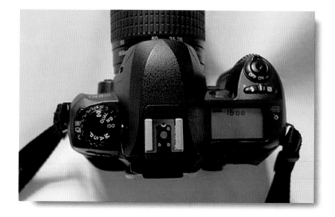

speed or sensitivity, take the picture and then switch back to the minimum setting as soon as you can (the camera will not prompt you to do this) because the higher sensitivity may result in lower-quality images. The variation in sensitivity is carried to extremes in the best SLR digicams, opening up some interesting creative possibilities.

Because SLRs (single lens reflex cameras) are made to take interchangeable lenses, they are far more versatile than cameras with integrated lenses. Several versions of conventional SLR cameras are now also available in digicam form, with standardised lens mounts, which means that an enthusiast who already owns a conventional SLR and several lenses can use the same lenses on an equivalent digicam.

The main disadvantage of using familiar lenses from your 35 mm-film days in an SLR digicam is that the lens-multiplier effect means that each lens does not produce the same result on a digital body as it does on a 35

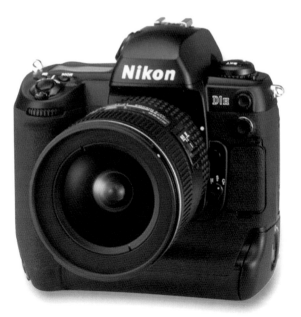

Figure 55 The Nikon D1H is a top-of-the-range SLR digicam. Although it does not produce the 6 megapixel shots of some of its stablemates (approximately 3 megapixels instead), it has a vast capacity for taking one shot after another for quite some time at the exceptionally high rate of 5 frames per second, making it a great favourite among sports photographers.

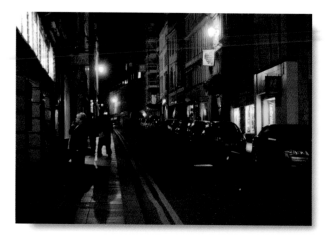

Figure 56 A picture taken with a hand-held digital SLR camera using a 50 mm lens set to f2.8, at 1/30th of a second and a film-speed setting of 1600 ISO, but no flash. There is no 'noise' effect visible when a 3 megapixel shot is enlarged to 10 x 8 in. (254 x 203 mm), although the picture looks 'grainy' at that size.

mm body: typically, a 75 mm lens used on a 35 mm-film camera, for example, will produce the same results as a 50 mm lens on a digicam. Or, to put it another way, the 50 mm standard lens on the film body is equal to a 75 mm lens when fitted to a digital body.

The SLR interchangeable-lens cameras often have a wide range of ISO settings (one of the Canons can be set between 100 ISO and 1,250, for example). If you use a higher setting, expect some loss of picture quality in the form of images that look 'gritty', an effect that may, however, suit some kinds of genre photography. Extremely high sensitivity often leads to what is called 'noise' – which is nothing that you can hear,

but may see in the image as dots of sparkling light in places where there should be shadow – a problem that tends to worsen with long exposure times, which often go hand in hand with the use of a very fast film speed when trying to take pictures in poor light (see also Chapter 7). Noise is sometimes not visible unless a picture has been enlarged considerably, however.

MEMORY
CARDS

MEMORY
CARDS

Memory, in the form of an electronic storage medium called a card, is either irremovably fixed or removably loaded into a digicam. The difference between the two is that you have to put up with the limitations of a fixed memory card, whereas you can swap a removable card with a replacement if you run out of capacity, or can replace it with a card with a larger image capacity to avoid running out of memory. If you have a camera without a removable memory card, there is nothing that you can do to increase

Figure 57

your shot capacity, which is why this chapter will focus on removable cards.

If you carry a digicam around with you, you can record objects of interest whenever you come across them. Many digicams allow you to make a voice recording, too, such as 'I must find out the name of this striped rose!' (See Figure 57, left.)

The kind of removable card required depends on the camera, although some can accept several types. Each type comes in a range of sizes, the lowest usually being 8 MB. Smaller sizes were made in the past, before

Figure 58 Five of the apparently ever-increasing number of memory-card types currently on the market. Clockwise from top: Sony Memory Stick, Secure Digital, Smart Media, Microdrive and CompactFlash.

multimegapixel cameras existed: one of the earliest successful digital-camera designs used the standard computer 3.5 in. floppy disc, with a capacity of 1.44 megabytes (MB), as the recording medium, for example. Today, when a full file shot recorded in the RAW format with a 6 megapixel camera could alone easily take up 25 MB, a high-volume memory like 1 gigabyte (GB) is almost essential for a computer. There are now about six different types of card, which is a nuisance if you are considering upgrading because the chances are that a new digicam will take a different card from the one that you already own, but then if you restrict your choice to suit your card, you may not be able to buy your preferred camera. More positively, however, your computer software will probably work just as well with a different camera. One of the reasons why there are so many card designs is progress, and each newer design offers an advantage over its predecessors. Memory Stick and Secure Digital both have a lock switch that enables you to write-protect the contents by pushing back the switch when you want to overwrite, for instance, which can be useful if you have several cards and are not sure which you have used.

Note that although a 256 MB card may be twice the size of a 128 MB card, this is only in terms of file capacity, not physical size. Not all memory-card types are made in the same range of sizes, although most are now available up to about 256 MB, and it probably won't be long before you can buy multigigabyte cards in several designs.

A BIT
ABOUT BYTES

In digital systems, the digital code is made up of a series of individual blips of signal, each of which is called a bit. Eight binary bits make a single byte, and there are 256 different combinations of plus and minus, or 0 and 1, in a byte (which is why there are 256 colours in 8-bit monitor-screen settings, see above). A kilobyte (KB, or Kb, which should not be confused with kb, which represents a kilobit) consists of roughly 1,000 bytes (rounded down from 1,024); a megabyte (MB, or Mb) consists of about 1 million bytes (actually 1,048,576); while a gigabyte (GB, or Gb) consists of 1 thousand million bytes. (Each number in the series is a thousand times larger than the previous one.)

Microdrive cards – the first to come onto the market comprising 1 GB and more – are interchangeable with CompactFlash cards, which currently range from 16 to 512 MB in size. A super Memory Stick card that takes large volumes of files is also available, and is sometimes interchangeable with the original version.

The larger the memory card, the more expensive it will be, which is why camera manufacturers generally supply small ones with their cameras (if they provide them at all). If the memory card that has been provided with your digicam is too small, which will usually be the case, it is best to buy another card containing as much memory as you think you will need and to keep the smaller one in reserve in case you ever run out of memory. Memory cards are becoming cheaper, and you will often see advertisements in camera magazines advertising memory and batteries at much lower prices than

those sold by specialist suppliers. Although the cost of different types of memory of the same size varies, the difference should not be so great that it influences your choice of camera.

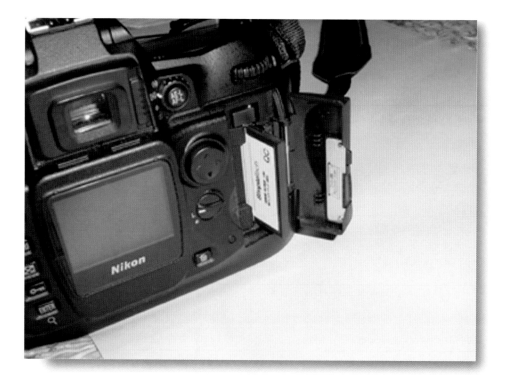

Figure 59 A Microdrive card in the process of being inserted into a digicam. Remember to switch off your digicam before inserting or removing any kind of memory to prevent such glitches as the battery going flat or images being erased.

HOW FAR DOES MEMORY STRETCH?

How far does memory stretch, or, in other words, how many pictures can you take before running out of memory? The key to answering these questions lies in file sizes. As an example, let's consider how many images it is possible to store on the 8 MB card or internal storage that is usually the minimum amount of memory supplied with a 3 megapixel digicam (although 16 Mb is fast becoming the norm), as well as on a 256 MB card. The table below assumes that the images have been saved with the standard degree of compression in JPEG (or JPG) format.

Looking at Table 1, you may think that the five pictures specified for an 8 MB card aren't nearly enough, but then these will be 3 megapixel-quality images of the minimum standard

TABLE 1
The image capacity of 8 and 256 MB memory cards

File size	Images on an 8 MB card	Images on a 256 MB card
2,048 x 1,536 pixels	About 5	About 160
2,048 in 3:2 ratio	About 5	About 160
1,600 x 1,200	About 8	256
1,280 x 960	12	384
640 x 480	118	1,418

required for good-quality printing. (If the camera is a 2 megapixel model, 1,600 x 1,200 is the largest file size that you can shoot.)

If the camera is a 5 or more megapixel model, as are most of the top-quality compact cameras and SLR types (including both the digicams with a lens fixed to the camera, but a wide zoom range, and the interchangeable-lens models, a few of which are even bigger), the number of pictures that you can bag before needing to reload your camera will decrease if a large file size is used, to about 60 per cent of the figures in Table 1, so that an 8 MB card will hold three images, and a 256 MB card around a hundred. If the file sizes are smaller, however, the number of images are as given above. Note that when you buy a camera with more pixels, you will also receive a bigger card, and 16 MB (double the figures given for a 8 MB card in Table 1 to see how many images it will hold) seems to be the smallest card provided with cameras of 4 and more megapixels. The 5 megapixel models will produce images of up to around 2,500 x 2,000

pixels (2,500 x 2,000 = 5 million), while 6 megapixel cameras are capable of producing 3,000 x 2,000 pixels. Remember, however, that all but the simplest cameras can create smaller or larger sizes, so that you may not be working with maximum-sized files all of the time. The largest semi-professional camera size is 6 megapixels, and Nikon, Canon, Contax and Fuji's models are usually designed to produce pictures of three different sizes: large, 3,008 x 2,000 = just over 6 million pixels; medium, 2,240 x 1,488 = 3.3 million; and small, 1,504 x 1,000 = just over 1.5 million. These are the three sizes that you are likely to use the most, but remember that you can always resize images on your computer.

The number of images that a memory card can store also depends on the picture's format (see pages 79–81). Is the file compressed in JPEG, or JPG, for instance? If so, how far is the file compressed? More compression means an increased loss of detail but far more images, while less compression means less loss of detail, but fewer images. Or is the file saved in RAW, which

preserves the maximum amount of detail at a maximum file size? RAW is a very useful facility for archived files that is being increasingly offered by some 3 and more megapixel compacts in which the accompanying data needed for handling a RAW file is not embedded in the file, but added as a tag. Who knows what format will be required in ten years time? And while other formats may merely be usable, RAW is future-proofed. In addition, it does not include any data, such as contrast variation, colour adjustment and sharpening, relating to the processing of the picture within the camera, giving the user the option of making any necessary adjustments later, unlike other formats, which

record the image after taking these factors into account, making it more difficult to make subsequent changes without incurring some loss of quality.

The more sophisticated digicams offer a choice of formats. The Nikon D range, for instance, enables you to save your images as RAW (NEF), TIFF, (RGB-TIFF), FINE (JPEG fine), BASIC (JPEG basic) and NORMAL (JPEG normal). (See the glossary on page 251 for an explanation of these abbreviations.) Table 2 outlines the number of images that can be stored in the various formats and file sizes using a Nikon D and 256 MB memory card. Note that because they are influenced by the size of the pixel array and a few other

TABLE 2

The image capacity of various formats and file sizes

File size	RAW format	TIFF format	FINE JPEG	NORMAL JPEG	BASIC JPEG
Large	25 images	14 images	75 images	148 images	285 images
Medium	25 images	25 images	134 images	259 images	485 images
Small	25 images	55 images	285 images	530 images	929 images

Figure 60 A street scene featuring a postman. Pictures like this that are full of detail can be enlarged to show even more if the file size is large enough. This was a 3 million-pixel shot.

factors, these figures will not exactly apply to every digital camera, but are nevertheless a close approximation.

You will note from Table 2 that the file size remains the same in RAW format. The three different figures for JPEG result from different degrees of compression, the purpose of compression being to reduce a file's size for storage only, the file then being decompressed, or 'unpacked', before use. The image loses some detail on being compressed, which is not restored when it is decompressed, so that a higher level of compression and a smaller file size creates a picture whose quality is less good when

subsequently viewed. In this instance, Nikon has given the user three choices: retain more detail, but store fewer pictures (FINE), or vice versa (BASIC), or else select the median option (NORMAL). It is arguable whether the 285 images in the large, BASIC file will be identical to the 285 in the small, FINE file, but, having been compressed further in the camera, the FINE file will take longer to process, and if you want to shoot a lot of pictures in a short time, you may grind to a halt until the processing has been completed. Alternatively, opt for less compression and faster processing (NORMAL OR BASIC formats).

Figure 61 A winter landscape. Photographs that include relatively little detail, like this landscape, can sometimes make good pictures when enlarged from a much smaller file than needed for Figure 60. In this particular photograph, any resulting graininess may be disguised by the frost on the field.

DOING
WITHOUT
MEMORY

You may be interested to know that you can do without memory, that is, as long as you have the right camera and your photography consists solely of studio work (perhaps if your focus is on portraiture or recording objects, such as a stamp collection) and you are working near a power source. Note that although you may be able to use a direct connection to power the camera,

Figure 62 You may find investing in a firewire set-up worthwhile if you regularly undertake studio work, such as photographing a collection of plants against a fixed backcloth as each comes into flower.

Figure 63 A simple flat-bed scanner, a cheap and simple option if you are planning to scan paper prints that is also capable of producing sufficient definition.

this is really only useful if you are a professional or semi-professional photographer. You will otherwise need video output and a direct-linking firewire capability, with a firewire cable running from a port in the camera into your computer's firewire or IE1394 port to enable your pictures to be directly transferred to your hard disc rather than a memory card. The advantages of using firewire is that it saves download time (a factor that may be important if large file sizes are involved because it can take an hour to download a full 3 GB memory card) and, indeed, removes the need to buy a memory card altogether.

You may need extra computer memory (random-access memory, or RAM) to handle the transfer, however, with 256 DDRAM being about the minimum amount of memory required for small files. And if you are scanning conventional photographs and require high resolution rates (more than 300 or 400 dpi, for instance), the 64 SDRAM provided with many computers will not be enough because the computer stores scans in RAM until the file-naming operation has been completed (see pages 169–178 for more advice on scanning).

FILE
FORMATS

Many cameras give you a choice of format in which to store an image within the camera, and you can then use computer software to make certain changes to the image once it has been downloaded onto a computer. Indeed, software can even reverse changes that you have made, for example, by restoring a picture saved in a certain format to its original format, although if it was subsequently compressed, it will not be the exactly same file because information is lost every time that a file is converted. A compressed JPEG file, for instance, will be compressed further still when moved and saved under a different name with the same JPEG termination, each such compression causing the file to take up less space, but always at the cost of losing a little more information. Because they result in a loss of detail, these compression systems are called 'lossy' systems, and although there are 'loss-less' compression formats, such as RLE, LZW and CCITT, which are primarily intended for use with photographs that consist of large areas of flat colour or monochromatic images, they are unsuitable for ordinary colour photographic purposes.

Posterised images are eminently suitable for use with the bitmap (BMP) format, which was designed for colour work. BMP is also very useful if lettering is added to a photograph – perhaps to produce a handbill or poster – in a word-processing application, many of which support BMP (as do most printers), but not JPEG. All that you usually need to do is open the file and then print the image. If you try to use BMP in a slide show, however, you may find that your image-handling programme cannot handle BMP. This is

Figure 64 A posterised image made up of only nine colours instead of the usual hundreds or thousands. This technique, which adds impact, is useful for graphics work. It is best employed when working with photographs that consist of simple shapes and bright, contrasting colours. (If you use it for a landscape, you may end up with just a green silhouette.)

why it is important take the purpose for which you want to use an image into consideration when selecting a format. (Note that Photoshop supports more formats than most, and that you may be able to convert a file by opening it in Photoshop and then saving it in your preferred format. If you want to vary the degree of compression without going to the expense of buying Photoshop, try visiting the xat.com website for a modestly priced optimiser.)

Figure 65 Photoshop allows you to posterise only the edges of an image. Compare this photograph with that in Figure 64.

Even if your applications can handle them, remember that BMP files are not suitable for delicately coloured images (because the result can sometimes be jagged edges), and work best with large blocks of plain colour, such as poster pictures, whose colour simplification has both charm and helps to focus attention on the poster's contents. It is easy to turn ordinary pictures into posters using the appropriate software and then, if memory space is an important consideration, to save them in BMP. (In Adobe Photoshop or the inexpensive Adobe Photoshop Elements, use the

commands Image/ Adjustments/ Posterise. Mac users should go to Image/Adjust/Posterise.)

For photographic purposes, JPEG (the abbreviation stands for Joint Photographic Experts Group, which created this format), or JPG, is the format that is the most widely accepted by different applications, making it the most convenient compressed format to use.

Other common formats include TIFF, or TIF, a format that preserves a great deal of the file's original information and is therefore useful when working with images that you want to use for publication, to make into very large prints or to create surreal images with in Photoshop. Files saved in this format take up a lot of memory space, however, but then you could always transfer them to a compact disc (you will be able to fit a lot of files onto a

Figure 66 The xat.com home page.

Figure 67 This picture has been posterised using the appropriate software, so that each of the three basic colours has been reduced to only four shades. A simple picture is given more impact by this treatment, and the file could be saved in BMP.

700 MB rewriteable compact disc, or CD-RW) and delete them from your computer's hard drive.

GIF files use some compression (or are capable of doing so), but can only handle 256 colours. Although they are suitable for web pictures, they usually produce less good-quality paper prints, which consist of a higher number of colours. If you are going to create slide shows with your computer's monitor screen set to only 256 colours, you would probably find this format suitable, but it's important always to make sure that your computer software

Figure 68 A historic mill building during the course of restoration, the sort of photograph that a local history group would probably wish to archive. RAW is the preferred format in which to save archived pictures, but if this is not available, TIFF should be used instead.

can handle it. If your slide programme works only with JPEG, for instance, do not consider using any other format. CD-Photo was developed by Kodak especially for transferring pictures to CD-ROM.

RAW, which was discussed on page 79, is often used by professional photographers who know that an image will be printed using CYMK (cyan, magenta, yellow and black) scales rather than the RGB (red, green and blue) that home printers use. Although software can convert these scales, a little detail will be lost, so if you know

that a picture is destined for a professional printing house and will be providing a copy of it on a CD, set your camera to work in CYMK rather than sRGB, if possible, and then save the file in RAW. (If your camera gives you the option and you know that you will be manipulating an image in Adobe Photoshop, another useful tip is to set the camera's colour mode to Adobe. Similarly, if you are shooting a landscape, note that sRGB II may give a subtly better rendering than sRGB I.

To summarise, JPEG both reduces file sizes and is suitable for images that will be posted on websites, sent by e-mail and saved within the camera or to CD. TIFF should be used for large picture files whose detail and quality you are anxious to preserve; TIFF should be used if you cannot save such pictures in RAW.

Finally, remember to consult your camera's instruction manual to see whether a particular format has special significance to your camera, or else consult a software programme's 'Help' feature for further information.

chapter 5

SOME OTHER
CAMERA
FEATURES

LIGHTING CONTROL

In comparison to matching the film types of conventional photography to lighting conditions, digicams really make life simple.

Perhaps you took a photograph inside in the pre-digital days, for example, and although the flash didn't fire, the exposure was good enough to imprint an image on your fast colour-print film, an image in which the subjects all had red faces and blue furnishings looked a strange hue. And maybe you then bought a 'tungsten', or 'artificial-light', film to compensate for this effect, and finished it off on a walk in the sunshine, with the result that your subjects all had blue faces. In the digital era, these are problems of the past now that most digital cameras, apart from the most basic, have a 'white-light balance control'.

Most medium-priced digital cameras (with 2, 3, 4 or 5 megapixels) and top-of-the-market digicams enable you to change the setting to compensate for a sunlit or overcast sky, and certainly for tungsten (ordinary light bulbs) and fluorescent lighting and flashlights (or leave the setting on 'A' for automatic and let the camera do it). Using the same memory card, you can select different settings for individual pictures. An 'auto-select' feature is also invariably included in the digicam's software.

Figure 69 White flowers are one of the severest tests of cameras and photographers. The exposure must be spot-on if both the details and shade of white are to be captured without degradation. If the colour is not 'true' a connoisseur of the species of flower may be quick to notice that the colour is not right. This is therefore an instance in which intelligent use of the white-light balance control is essential.

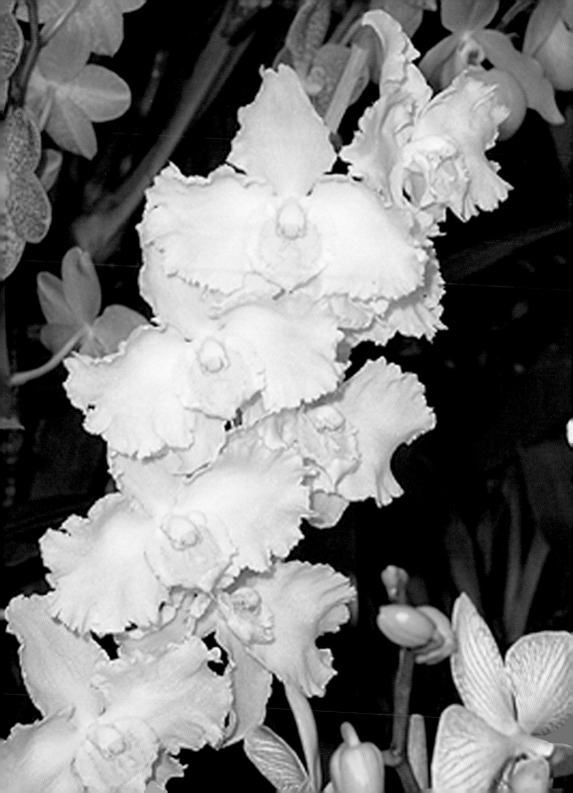

CHARGING UP

How are digital cameras powered? The answer is that digital cameras run off batteries, a power source on which some cheaper cameras skimp. Avoid digicams that use ordinary AA, or, even worse, AAA, batteries if you can, including ordinary photo-lithium, silver-oxide, zinc and alkaline batteries, that is, unless you are forced to opt for a camera without an LCD (LCDs leach the life out of batteries). Many cameras nowadays use rechargeable lithium batteries, such as the Li-On battery seen in Figure 31 (page 41), nickel-cadmium (NicCd) batteries, and, better still, nickel metal-hydride (NiMH) batteries, all of which can be recharged repeatedly (but not endlessly), and in any case offer a much more useful current charge. Some manufacturers include a recharger with their cameras, while others make you pay extra for them, in which case it's advisable to

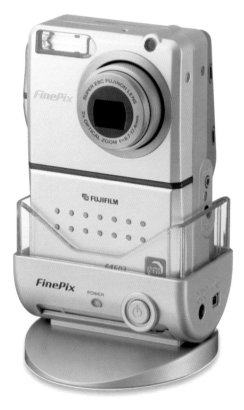

Figure 70 A digital camera in its charging cradle. Several models are recharged in this way. Alternatively, a lead is plugged into the camera or the batteries are replaced.

Whatever type of battery you use, remember that handling your camera incorrectly, perhaps by plugging in a USB download cable without switching off the camera, or by removing the memory card while the camera is still switched on, may flatten the battery (and maybe do even worse damage), so read your instruction book carefully before using your camera.

Figure 71 The modern way of charging a digicam's batteries is to drop the camera into a dock.

Figure 72 Casio's super-slim Exilim EX-S3, pictured in its charging dock, which doubles as a support when the camera is used to stage a mini-slide show.

check whether the camera will charge up a spare battery before investing in a recharger.

Some photographers regard rechargeable batteries as a nuisance, however, because if they run out and you do not have a spare to hand, your camera will be temporarily out of action. Yet if you use your camera a lot, a rechargeable battery will soon pay for itself in terms of packs of non-rechargeable AA batteries.

LCD
SCREENS

The liquid-crystal display (LCD) screen is a bright screen (see also pages 96 to 99) that shows you what the lens is looking at, thereby giving you the option of composing the photograph in a different way. You can also view the photographs that have already been taken by switching the camera from 'record' to 'play' mode. The LCD screen is one of the camera's most important components because it enables you to check that you have recorded the image that you intended to capture.

LCD screens vary in size from 1 in, (38 mm), through 1.6 and 1.8 in (40– 46 mm), which are very common, to the 2.5 in. (64 mm) of the Sony Mavica. Other cameras that have large LCD screens include the Fuji FinePix M603 and the Panasonic Lumix. Some digicams' LCD screens also include a

Figure 73 Macro photography involves taking large pictures of small things so that the frame is filled. With the lens being only a couple of inches away from this coin, for instance, lighting is a crucial and difficult consideration. It is advisable to mount the camera on a fixed support to ensure that the focus is spot on and that the camera doesn't move when the photograph is taken.

Figure 74 The following considerations were taken into account before taking this photograph. Because the roof of the bandstand cast a shadow over the members of the band, a front view would not have been very exciting. The reflections on the tubas looked as though they would add interest to a picture, however, and two tuba players sitting side by side, framing the conductor, looked like a good composition. But when the picture was taken and viewed on the LCD screen, it was clear that one of the bandstand's uprights divided the picture into two halves, spoiling it. This photograph, which is much more satisfactory, was taken after moving around and experimenting with different angles.

magnifier, which is helpful when looking at a small object in macro mode, when the camera is very close to the object, an image of which fills the screen.

LCD screens are just large enough to give you a general impression of how a photograph looks, enabling you to check that you have not cut off a person's head or posed someone badly,

for instance, something that you may have missed when looking through the viewfinder, but is glaringly obvious when you view the picture on the LCD screen. LCD screens can show you whether you need to take a shot again, but note that not even the best will show you that the lens's focus was spot on, although it may reveal that you took a picture on a macro or manual setting at a particular exposure value and then forgot to switch it back, with the result that the subsequent image is grossly under- or overexposed or even entirely out of focus. A good LCD screen is therefore an important ally in helping you to get the pictures you want, as long as you remember to use it properly.

Some cameras have a switch that turns the LCD screen off and on, enabling you to save battery life by only switching on the LCD screen when you need to and otherwise using the eyepiece viewfinder to compose a picture. Other cameras, especially SLR or SLR-type digicams, automatically illuminate the LCD screen for only a few seconds after each shot, although

you can use the software in the camera to review images in a built-in slide show. The disadvantage of composing a picture using the eyepiece viewfinder is that it typically excludes the edges of the image that the lens sees, or else shows more than it sees, so that you may include something that you wanted to avoid in a picture or vice versa. By contrast, the LCD screen usually shows the picture that has been taken fairly precisely.

It is important to remember that the amount of current needed to take a photograph is tiny, while the amount used to illuminate the LCD screen is relatively large. Lithium batteries, in particular, carry a lot of charge and last for a long time (typically for over an hour, and sometimes for nearly four hours), so that when a camera is fully charged, it is likely to be capable of taking all of the shots that the memory card will hold. Indeed, the battery in those SLRs whose LCD screen is only lit briefly, rather than those whose screen is lit for as long as the camera is switched on, can easily power the taking of a thousand images.

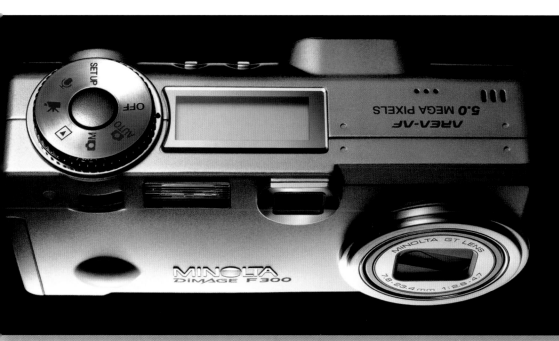

Figure 75 The slim Minolta Dimage F300, shown with its lens retracted.

Cameras whose LCD screens remain on while they themselves are switched on will usually switch themselves off automatically when they have not been used for a few minutes. Those whose screens are rarely illuminated may remain on until they are switched off, but if accidentally left on for days, may sometimes still contain enough charge to enable them to be used. This should not be relied upon, however, so get into the habit of switching off your camera manually when you have finished using it. Another reason for switching off your camera is that it causes the lens to retract (switching it on extends it), thereby protecting it from being accidentally damaged.

MOVIES, ACTION PHOTOGRAPHY AND SOUND

Most digicams have a 'movie' setting and a built-in sound-recording capability. Digicams do not produce video-camera-quality movies, however, because they usually record at around 12 to 15 frames per second (fps), with the result that movements appear jerky, rather like in ancient silent movies, when the action is replayed. Because a lot of processing has to be done within the camera, the buffer memory is of limited size, and the file size will in turn be very small. So do not expect a good, sharp, nicely exposed, megapixel shot suitable for enlargement, although you may be pleasantly surprised if you are not expecting too much.

If you are trying to analyse a golf swing or diving action, using the movie facility as a sort of super-motorised shutter, for a limited burst of shots (which is why it is sometimes called 'burst mode'), may give you something to work with. A movie's maximum length will vary from camera to camera, from 10 seconds to the time that it takes for the memory to become full, so if you intend to take action shots, this is something to check before buying a digicam.

On the subject of action photography, a serious criticism of some digicams is the delay that occurs between pressing the shutter release and the picture being taken, which can make it difficult to capture an important moment in the action. The delay may be due to a slow automatic focus (AF) or a slow automatic exposure (AE), making this another area to check before buying a digicam. If you already have a camera and are experiencing such a delay, check whether you can switch off the offending mechanism. It

Figure 76 One of a series of four pictures taken using 'burst mode' while the shutter-release button was held down, which is about the only way of capturing a particular point in a rapid action sequence.

may be that you can set the focus to manual and choose your preferred distance, for example, so that when you try to take the picture, the camera will not spend that vital fraction of a second checking the focus. You may similarly be able to disable the AE function if exposure assessment is causing the delay. Before buying a camera, also check the time that it

Figure 77 A digital camera can enable you to capture the moment when a sugar cube drops into a cup of hot milk.

takes between the camera being switched on and being ready to take a photograph, which may range between 1 and 10 seconds.

If you are keen to become an action photographer, it is best to buy an SLR-type of digicam, with a facility that sets the shutter to take single or multiple shots at, for example, a rate of 4 fps. You should then use a selected-follow-focus system, or else switch off the AF facility, so that the camera doesn't try to obtain the perfect focus after you have pressed the shutter-release button. (Even then, it's best to start shooting before the critical moment.) Working at 4 fps with a 5 megapixel camera containing a decent processor should give you a

Figure 78 Before taking an action photograph, focus on the space, then switch off the auto-focus facility so that there is no delay between the shutter-release button being pressed and the picture being taken. If possible, also switch off the auto-exposure facility, which will save microseconds.

large enough buffer, and hence file size, to produce images that you can enlarge, for instance.

The sound provided in digicams may be one of two kinds, or both. One is sound recorded with a movie clip; the other is sound added to each still shot, enabling you to use the camera as a notebook. The thing to check in this instance is how this feature is activated. If you have to go to 'menu', select 'camera', select 'sound', select 'on', select 'confirm' and then press a

button while you talk, and have to repeat this procedure to set up the camera for the next shot, it will not be of much practical use as a notebook. Imagine going round a flower show and making notes about a lot of flowers in this way – you would be in danger of ending up with repetitive strain injury and would certainly be yearning for an old-fashioned notebook!

Figure 79 A flower show at the Royal Horticultural Society's halls in London. The lighting is not too good for photographic purposes in places like this, although flash may be an option for close-ups. If quite a long exposure is necessary, look for somewhere to rest or brace the camera to steady it before taking this kind of general shot. In this case, it was necessary to use a 200 ISO setting, f4.5 and a shutter speed of 1/80th, but because the lens length was only 28mm (effectively 42mm), there was no problem in holding the camera steady.

ABOUT
LENSES

ABOUT LENSES

In conventional, 35 mm photography, lens focal lengths are standard and widely understood, unlike in digital photography, in which such figures are almost meaningless. This is why the manufacturers of digicams quote the focal length of their lenses as being 'equivalent to [whatever in 35 mm photography]', meaning that a digicam's lens will give the same effect as the specified single-lens reflex (SLR) lens in a conventional camera, for example.

Figures 80 to 84 This series of photographs illustrates the difference between various lens lengths. All of the photographs, taken from progressively further distances, show the same signpost. Figure 80 was taken from only a few feet away with a 24 mm lens; Figure 81 was taken with an 85

Figure 80 This photograph was taken with a 24 mm lens.

Figure 81 This photograph was taken with a 85 mm lens.

Figure 82 This photograph was taken with a 135 mm lens.

mm lens; Figure 82 was taken with a 135 mm lens; Figure 83 was taken with a 200 mm lens; and Figure 84 was taken with a 450 mm lens. Note how the distant trees seem to rise up, especially in Figure 84, as well as how the cattle in the distance are initially too small to discern, then appear as dots and can eventually be seen more clearly. The photographs show that although the main subject remains approximately the same size, the choice

Figure 83 This photograph was taken with a 200 mm lens.

Figure 84 This photograph was taken with a 450 mm lens.

of lens affects the relative sizes of objects in the more distant parts of a photograph, as well as those that are nearer to the viewer than the main subject – in short, they illustrate how different lenses affect a picture's perspective.

FOCAL LENGTHS

The 50 mm lens is standard, and is supposed to have the same angle of view as the human eye. The 85 mm lens is the norm for portraiture (it doesn't distort noses when taking close-ups). Any lens whose focal length is more than 135 mm is a telephoto lens, which should be used with caution unless the camera can be steadied, ideally on a tripod. The 35 mm lens is a wide-angle lens; the 28 mm lens is a very wide-angle lens; and the 24 mm lens is an ultra-wide-angle lens; while any lens with a focal length of less than 24 mm is a fish-eye lens, which, unless the lens is enormous in size or is used very carefully, usually results in a great deal of distortion, as if the picture were being viewed through a gold-fish bowl. Figure 85 shows the pier at St Petersburg, in Florida, and was taken with a 15 mm lens in order capture as much as possible without the photographer

Figure 85 The most severe distortion, especially of vertical objects, occurs when a short-focal-length lens is used, especially when it is not held perfectly level.

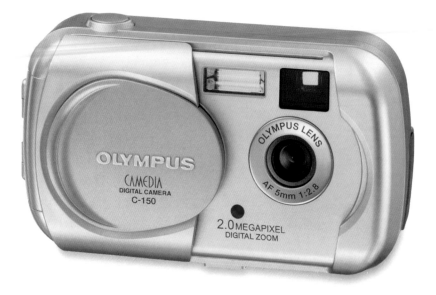

Figure 86 The Olympus Camedia C-150. Its lack of a zoom lens makes this camera compact and light. It is also very simple to manage and handle.

having to step backwards and risk falling into the sea. With the lamppost leaning one way, and the roof the opposite way, this illustrates the kind of distortion in perspective that it is all too easy to produce when using short-focal-length lenses.

In conventional photography, the focal length is the distance between the centre of the lens and the film. The comparable figures provided for digicams – not the 'equivalents' because digital cameras are quite different – are much smaller, sometimes only 5 to 15 mm for a camera with a 3:1 zoom. This is because a digicam's CCD (charge-coupled device), effectively the pixel array, is almost invariably smaller than a conventional film frame, so that the focal distance has to be much less if the angle of view is to be the same. If a CCD were the size of a 35 mm film (36 x 24 mm), it would have to have a very high

pixel count to fill up the space, and would require a lens of a similar focal length as a film camera's to produce the same results. A smaller CCD therefore equals a smaller focal length, and unless you know the exact size of a digicam's CCD, you will have to rely on what the manufacturer says is the lens' equivalent focal length. This also explains why most SLR digicams with 50 mm lenses produce the same picture as a conventional SLR fitted with a 75 mm lens. Only the central part of the potential image can be used because the CCD is smaller than the 35 mm film frame. The ratio between the film frame size and the CCD size leads to 'the multiplier factor' or effect – typically about 1.5, meaning that the 200 mm lens on a Canon EOS SLR film camera, when swapped wth a new digital camera will give pictures looking as though they were taken with a 300 mm lens. The multiplier effect varies from model to model, ranging from a maximum ratio of about 1.75 to a minimum of about 1.4; 1.5 is therefore a convenient figure for discussion.

Figure 87 A rear view of the Olympus Camedia C-150.

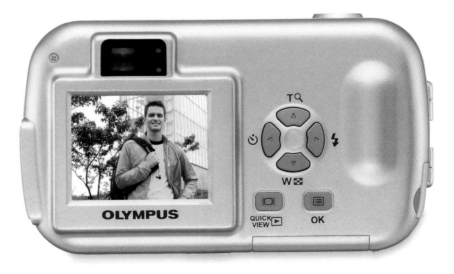

ZOOM
LENSES

Many digicams have zoom lenses, but note that some are specified as having 'optical zoom' and others as having 'digital zoom', while some have both. It is important to understand the difference between the two types of zoom lens.

An optical zoom produces exactly the same effect as a conventional camera's zoom lens, that is, it magnifies the image. The typical optical-zoom lens has a range of 3.1, meaning that the lens can be zoomed from a focal length equivalent to that of a conventional 35 mm lens to one equivalent to that of a 105 mm lens. Some cheaper mid-range compact digicams have a less desirable optical-zoom range of only 2:1, while a few more superior mid-range digicams

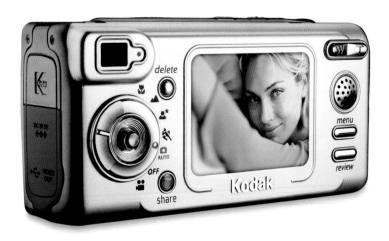

Figure 88 A rear view of the Kodak EasyShare camera (a front view is shown in Figure 21), which has a 3.1 megapixel capacity and a 3:1 optical zoom. It is a typical mid-range compact camera, and will make an ideal first camera if you are new to digital photography.

Figure 89 The Olympus Camedia C-750 is the top-of-the range model, with, at 10x, the largest optical-zoom range.

have a zoom range of 4:1. A 4:1 optical-zoom lens is better than a 12x combined optical-and-digital-zoom lens if the optical is 3x and the digital is 4x (3x x 4x = 12x).

When a digital zoom is used, the image is recorded on a smaller part of the CCD before being magnified using that smaller part of the array only, or else spreading the picture over the entire array via the processor and

interpolating signals. More usually, in combined optical and digital zooms, the digital zoom takes over when the optical zoom runs out. However the image is digitally magnified, there is loss of quality, so that when a digital zoom is used, a 3 megapixel camera with a 3x digital-zoom lens zoomed out to full magnification will give you an image of the same quality as the best produced by a 1 megapixel camera, and no more.

It's therefore best to be sceptical about the overall zoom figure and to pay particular attention to the optical-zoom figure. One problem with many digital cameras is that the camera, not the user, chooses which of the two zooms is used, so look for a camera that enables you to switch off the digital zoom when you want an image of the best-possible quality, or else one that indicates which zoom is being used.

Does this mean that a digital zoom is of no value? Not at all. It all depends on what you intend to use your camera for, as well as what sort of camera you can afford. If you don't want to make big enlargements, for instance, a relatively inexpensive 3 megapixel camera will probably suit you very well, whatever its zoom type. In addition, if you intend to have your prints made for you, and anticipate wanting to make only the occasional enlargement from an entire picture, a digital zoom would probably still be fine. If you

Figure 90 The HP Photosmart 850 has an 8.1x optical zoom, as well as a 7x digital zoom, making its range one of the largest offered by any digital camera.

Figure 91 The Kyocera Finecam S4. This camera has a 3x optical zoom that works first, after which a 4x digital zoom (which can be switched off) takes over. The digital zoom can also be used to enlarge the captured image on the LCD screen in order to check its details. When it is switched off, the entire lens retracts into the camera.

intend to enlarge a portion of a picture so that only a fraction of the whole image is enlarged, you will require a digicam that produces better-quality images, however, which means focusing on buying a camera with a higher number of pixels and disregarding the digital-zoom issue!

SLR

LENSES

For best-quality photographs, you will need a best-quality lens, which means buying a single-lens reflex (SLR) digital camera, whose eyepiece you look through to see through the lens. This has a conventional-style body designed to accept interchangeable lenses, including the lenses made for the conventional version of a particular camera, giving you a vast selection to choose from. And not only can you use Nikon lenses with a Nikon camera, for example, but lenses made by other manufacturers, too, such as Tamron, Sigma and Tokina, some of which offer fantastic value for money, particularly if you're buying a lens that is out of the ordinary, such as a long-focal-length macro lens, which is capable of taking large pictures of tiny things; a perspective-control lens for architectural work; or a vibration-resistant lens for the long, telephoto

lenses used in sports photography. The digital SLR will be the camera of choice for many serious amateur photographers who already own a conventional camera and several lenses, simply because they need only buy the camera body. Note, however, that these cameras are among the most sophisticated and complex of cameras, but not among the cheapest.

To illustrate what particular lenses are capable of, figures 92 to 97 show a series of shots taken from one position with a 15 mm, 30 mm, 70 mm, 135 mm, 200 mm and 300 mm lens respectively and with a 1.5 multiplier effect. (Compare this series with figures 80 to 84 (pages 107–108), which show the effect of using longer and longer lenses to photograph an object while moving ever further away from it.) Using lenses with different

Figure 92 This shot was taken with a 15 mm (22 mm) lens.

Figure 93 This shot was taken with a 30 mm (45 mm) lens.

focal lengths results in pictures taken from different viewing angles, so that using different lenses, but varying the camera position, results in more or fewer details being included in the composition. Keeping the camera position fixed, but varying the lens, keeps the perspective constant, but shows the central area in different sizes. Because the position of the camera affects perspective, it would

therefore be an oversimplification to say that using successively longer lenses is the equivalent of moving nearer to the subject.

Figures 92 to 97 In the captions, the figures set in brackets are the effective lengths, due to the multiplier factor (explained on page 111). You will see that the perspective is unchanged in each of the pictures. In fact, if the

Figure 94 This shot was taken with a 70 mm (105 mm) lens.

Figure 95 This shot was taken with a 135 mm (200 mm) lens.

picture taken with the 300 mm lens (Figure 97) were to be replaced with the tiny central area of the photograph taken with the 15 mm lens (Figure 92), enlarged to the same size, there would be no difference in the images (apart from the inferior quality of the over-enlarged small photograph), which is why optical zooms are better than digital zooms and why a long lens can give better results than a short one.

One benefit of the multiplier effect is that while a 300 mm lens may be equal to a 450 mm lens in terms of what it shows, it is a great deal lighter and smaller. And although most photographers love long lenses because they make it so easy to take close-up shots, such as of birds and other forms of wildlife, they are more difficult to use because any slight movement of the camera is magnified in the same way as

Figure 96 This shot was taken with a 210 mm (315 mm) lens.

Figure 97 This shot was taken with a 300 mm (450mm) lens.

the image. The images will therefore not be very sharp unless the camera is either fixed to a steadying tripod or a very short exposure time is used.

Although the amazing technology of Nikon's VR (vibration-resistant) lenses, among others, counteracts the effect of camera movement to some extent, enabling the taking of hand-held shots at long focal lengths, such lenses are

very expensive. An alternative is to use as short an exposure as possible. A good rule of thumb is that the exposure should be the same, or less, than the lens' focal length, in other words, that it should be the reciprocal of that figure. This means that 1/50th of a second is fine for a 50 mm lens, as is 1/200th of a second for a 200 mm lens, and if you are a budding paparazzo who wants to snatch

Figure 98 An old Sigma 450 mm lens (below), dating from the days when such lenses were very large. The Nikkor 70–300 mm zoom lens above illustrates how small these lenses are today, even when they have a long 'tele' extension. Nikon's G-series lenses are particularly lightweight because they do not have built-in iris rings (relics of twentieth-century cameras that are unnecessary in modern designs because the camera now performs their function).

photographs of royals and film stars from long distances, your 1,000 mm lens will need an exposure of 1/1,000th of a second or less, which can be problematic unless the light is good. But then digital cameras enable fast film-speed equivalents to be used, which shortens exposure times.

The multiplier effect has a disadvantage, however, namely in connection with the wide-angle lenses used with digital SLRs. When fitted to a digital camera, a conventional 35 mm wide-angle lens is now almost the equivalent of a standard lens; a 28 mm wide-angle lens is the equivalent of a

Figure 99 A gargoyle atop a church tower, which was picked out with a 300 mm focal-length lens that is equal to a conventional camera's 450 mm lens, although it is almost half its length and a fraction of its weight. The photographer lay on the ground to obtain the right angle and viewpoint, steadying the middle of the lens on a gravestone.

slightly short standard 42 mm lens; a 24 mm wide-angle lens is the equivalent of a normal 35 mm lens; while a fish-eye 21 mm lens is equal to a 30 mm lens, which may be good, but not good enough if you cannot back away far enough to include all of the desired elements in a photograph. Help

Figure 100 Sigma's 15–30 mm zoom lens, which, taking the multiplier effect into account, is the equivalent of an average SLR's 22–45 mm lens.

Figure 101 A lightweight Nikon 12–24 mm G series zoom lens.

is at hand for users of Nikon SLR digicams, however, as well as those that accept Nikon lens mounts (for example, Fuji) because even the least wide of the following lenses is equivalent to a lens of under 30 mm once the multiplier effect has been allowed for: the Nikon 12–24 mm zoom lens shown in Figure 101; the less expensive Nikon 18–35 mm zoom lens; the Sigma 15–30 mm zoom lens pictured in Figure 100, which offers incredible value for money; and the modestly priced Tamron and Tokina 19–35 mm zoom lenses.

Figure 102 Being of a fixed length rather than being a zoom lens, this 17 mm Tokina lens is relatively simple and light..

Figure 103 The Tamron 17–35 mm zoom lens.

If you are starting from scratch and are thinking of buying an SLR digicam, but do not already own specific lenses that will influence you to buy a matching camera, consider an SLR-*type* camera. Such digicams, which are manufactured by Minolta, Olympus, Nikon and other makers, tend to be nearly as versatile as an interchangeable-lens SLR, retain the SLR's advantage of enabling you to look through the lens, but have a built-in, non-interchangeable zoom, ranging from 4:1 in the Olympus Camedia, through 7:1 in Minolta's amazing Dimage 7i, to 8:1 in Nikon's Coolpix 5700. The big advantage of having a camera with a built-in, non-interchangeable zoom lens is that your camera will never be fitted with the wrong lens when you need to take a picture in a hurry.

Turning to interchangeable-lens cameras, and apart from using one or more lenses to give similar results to the attached zoom of the SLR-type cameras, you also have the option of using a specialist lens, such as a super-macro lens, a super-long telephoto lens or an ultra-wide lens. You would pay a lot more for an interchangeable-lens SLR than for one with a built-in, non-interchangeable zoom lens, however. A compromise would be to buy a 'big-name' manufacturer's camera body, but less expensive lenses from a camera-accessory manufacturer like Sigma or Tamron.

Figure 104 Minolta's Dimage 7i is a 5 megapixel camera with an amazing 7x optical zoom. Although it has the kind of sophisticated controls offered by most good SLRs, it does not have interchangeable lenses. Its lens nevertheless marks it out as being an exceptional camera: the zoom range is the equivalent of 28 to 200 mm. The shutter speeds range from between 1/4000th of a second and 15 seconds; there is a special 4x magnifier on the viewfinder for use in macro (ultra-close-up) photography; there are nine choices for white-light balance control; the film-speed equivalents range from 100 to 800 ISO, equal to a sensitivity range of three stops; and it is capable of taking a IBM 1 GB Microdrive memory card.

Figure 105 Tamron's 28–200 mm and astonishing 20–300 mm lenses are available in fittings that will suit most SLR cameras made by the 'big-name' manufacturers, and at a fraction of the price of their own lenses.

Super-fast lenses with apertures wider than those of f2.8 lenses are only occasionally built into digicams, but if you have a true SLR, you can opt for one from the range of lenses made for conventional cameras. Such lenses enable fast shutter speeds when photographing sports, or when the sun is not shining, and, when combined with uprated sensitivity, make it possible to photograph at night without a flash. If you are thinking of buying a fast lens, note that the zoom will be specified as having an aperture range rather than a single figure being given. The Nikkor 70–300 mm zoom shown in Figure 98 thus ranges from f4 at the shorter end of the zoom to f5.6 at the longer end.

Figure 106 The Tamron f2.8 90 mm macro lens will focus downwards to produce 1:1 scale pictures on the film or sensor, so that an object that is maybe 1 in (2.5 cm) or so wide will fill the frame.

Figure 107 The f1.4 Nikkor, which is two stops faster than a f2.8 (the best that most digicams offer) and three stops faster than a f3.5. Most manufacturers of interchangeable-lens SLR cameras make very fast lenses.

And if you are looking at lens manufacturers' price lists and find one that offers two versions of a zoom, perhaps one with a f2.8 stop as the maximum, and another with f3.5 as the maximum – a difference of a whole stop (see Chapter 8, pages 156 to 159) – you will usually also find that the faster (wider-aperture) lens is twice the price of the other.

chapter 7

PHOTOGRAPHY IN POOR LIGHT AND IN THE DARK

PHOTOGRAPHY IN POOR LIGHT AND IN THE DARK

The best digicams can be set to the equivalent of an enormously fast film speed, and most of the latest can crank up the ISO rating far beyond the 400 ISO figure that is the highest offered by conventional film. SLR-type digicams can be set in this way, too – the Dimage 7i shown in Figure 104, for instance, can be set up to 1,600 ISO – but even if your chosen camera cannot match these figures, it will almost certainly work far faster, and with more sensitivity, than a conventional camera. If this feature is important to you, perhaps because you are interested in trying your hand at night photography, check a camera's specification before buying it because manufacturers reserve the right to change their products' specifications.

Extra sensitivity is a very useful tool in a camera indeed, especially when you want to take a photograph in poor light or in the dark, which does not necessarily mean at night (although street photography by night is always a possibility), but perhaps in a dark interior, such as inside a church. The human eye is far more adaptable than any optical device currently available to ordinary camera-users, and scenes that the eye can make out clearly (when it has adjusted to the dark conditions), can be impossible to photograph with conventional methods without using an overly long exposure (when a tripod is necessary) or a flash gun. And flash photography is often banned in art galleries and museums because it can damage fragile antiques (being exposed to too many flashes is the equivalent of baking in the sun).

Figure 108 This photograph was taken at the Kennedy Space Center, Cape Canaveral, Florida, in a museum hangar housing the Apollo spacecraft, and shows the rear end of the Saturn moon rocket. The rocket is huge, and the interior was far too dark to enable it to be photographed successfully using a conventional camera (1/15th of a second at f2.8 with a 400 ISO film would have been necessary, so slow as to need a tripod, while using a flash would merely have illuminated the nearest portion of the rocket). The settings chosen here, including an ISO sensitivity uprated setting, enabled a good picture to be taken with a hand-held digicam, with an exposure of 1/125th of a second at f4. An A3 print of this photograph, produced from the original 3 megapixel shot saved in TIFF, looks good.

Figure 109 There is a theatre at the Kennedy Space Center where the Apollo moon-landing launch is re-enacted. Although photography is permitted, the use of flash is banned. This picture was taken during just such a re-enactment. The exposure details are: ISO 6,400, 1/25th of a second at f3.3 and a 28 mm lens.

Figure 110 Vintage cars photographed at the Henry Ford Winter Estate, Fort Myers, USA. Exposure data: 1/60th of a second at f3.5, with the sensitivity upped to ISO 800. Flash would have left the distant car lost in the gloom.

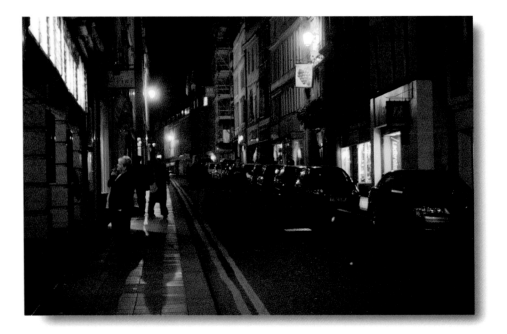

Figure 111 A night-time street scene gently illuminated by street lighting. Exposure data: a 28 mm lens, 1/30th of a second at f2.8 and 1,600 ISO

FILM SPEED, EXPOSURE AND SENSITIVITY

Remember that correct exposure depends on three factors: the film speed, shutter speed and lens aperture (refer also to Chapter 8 starting at page 150 and especially page 156 onwards). If you have a film speed of ISO 100, which is fairly typical of good-quality, fine-grain, conventional roll film, a normal daytime exposure would be perhaps 1/100th of a second (the shutter speed) at f8 (the lens aperture). But if your lens will open up that far and you are working in manual mode, you could equally well set it to 1/200th of a second at f5.6; 1/400th of a second at f4; 1/800th of a second at f2.8; 1/1,600th of a second at f2; or 1/3,200th of a second at f1.4 and so on. Because a shorter time multiplied by a larger lens aperture equals the same amount of light reaching the film, each of these settings gives the same exposure.

Figure 112 Bath Abbey, illuminated by its own floodlights. This photograph was taken with a hand-held camera. The exposure details are 1,600 ISO, 1/60th of a second at f4 and a 50 mm lens (effectively a 75 mm lens).Note the absence of any 'flare' around the street lamps.

Focusing on film speed, 1/100th of a second at f8 with 100 ISO is the same exposure as 1/50th of a second at f8 with 50 ISO, or 1/200th of a second at f8 with 200 ISO. With conventional celluloid film, the fastest available speed is usually 200 ISO, or occasionally 400 ISO, which can present something of a problem in really bright light – perhaps on a beach in the summer sun – when you may have difficulty setting a small enough exposure to avoid overexposed pictures. (And many photographers in any case think that 400 ISO does not give quite as good results as the slightly slower 200, or, better still, the 100, ISO film.)

In a poor light situation, when you are struggling even with a 400 ISO film, and the camera wants to set the exposure to quarter of a second at full aperture, increasing the aperture setting by four stops takes you back to 1/64th of a second, which is perfectly acceptable for wide-angle and standard focal-length lenses, although a longer lens will need to be steadied on a tripod or carefully braced or rested on a support in order to avoid the image being blurred as a result of camera shake.

Digicams with high ISO settings open up the possibility of taking photographs without using flash in a number of very interesting areas, and the examples illustrated in figures 111 and 112, for example, represent only the tip of the iceberg of possibilities. It is as easy to take photographs in the street at night, with only ordinary street lighting illuminating the scene, as it is to photograph floodlit buildings without having to carry a tripod around. And genre photography – snapping a real-life scene without drawing attention to yourself with a flash – is a great area of photography to get into.

When very high sensitivity is used, it creates the possibility of an image being affected by 'noise', which will appear as bright, random spots of colour that do not belong in a picture. This is why increasing the sensitivity is a last resort when trying to take photographs in poor light, but note that because noise is due to the pixels overheating, long exposures make it even more inevitable, so that using a higher sensitivity and a shorter exposure as compared to a lower sensitivity and a longer exposure have

FIGURE 113 A church interior photographed in natural light with a hand-held digicam. Exposure data: 1/60th of a second at f4 and 1,600 ISO.

equal advantages and disadvantages. If you want to take a particular shot, and risking 'noise' is the only way to get it, however, then the choice is clear: a picture with a few odd dots on it may be vastly preferable to no picture at all. Some of the latest digicams have an in-built ability to avoid this risk of noise due to long exposures, and should result in improved shots taken at increased ISO ratings as well.

FIGURE 114 A photograph taken in an art gallery where the use of flash was banned. The photograph was taken using the fast f2 setting on a Sony Cyber-shot digicam, at 1/30th of a second, without it being necessary to enhance the sensitivity.

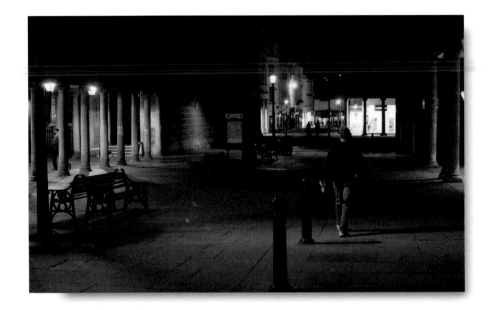

Figure 115 A night scene illuminated by the available light, taken at 1/50th of second at f4 and on a 6,400 ISO setting. The picture's composition required the walker to be in this position, but a longer exposure would have caused the moving figure to look blurred, which was not wanted. If this picture were to be enlarged to the point where it starts to break up (more than A3 size), lots of noise spots would be seen, and although they could probably be touched out, many could be regarded as odd reflections of the street lights (which some may actually be).

In genre photography, moving people may look a little blurred, but this is often acceptable because it adds a natural effect, while a certain graininess or grittiness may add to the real-life, unposed appearance of a picture, which is great for photo-journalism. High sensitivity is also a boon for undercover work because the lack of flash means that you won't be drawing attention to yourself or your activities, Your unsuspecting 'models' are unlikely to object to being photographed because they will not even suspect that you have taken their picture.

APERTURE
PRIORITY

You should select the aperture-priority feature when you are concerned with the sharpness – or otherwise – of different areas of a picture. Do you want the subject to appear sharp and the background out of focus? If so, use this feature. Do you want every aspect of the photograph to look sharp? If so, use this feature, but use it differently.

It is a feature that is increasingly being demanded by buyers, and is therefore increasingly included in digicams. Note, however, that although

Figure 116 To set the aperture priority when using a Nikon SLR, first turn the function dial on the left so that it is aligned with 'A' (for aperture), then turn the command dial on the right until the desired aperture is shown in the display window. F22 has been chosen here. Leave the controls in these positions. The auto-exposure will now vary the shutter speed to suit the light. Setting the shutter priority is a similar process, except that the function dial is set to 'S'.

some new designs are advertised as having it, they actually offer a very restricted choice of apertures, maybe only two. And if you are a serious amateur photographer who is already familiar with the feature and are thinking of investing in a digital camera, you should know that the effect is better with longer-length lenses, but because all except the top-of-the-range digicams have short lenses, it will not work quite as well as in conventional photography.

This control is usually selected by turning a knob or wheel, or by pressing a programme switch and then selecting the aperture (if your digicam has this feature, the handbook will tell you how to access it). Figure 116 details the selection process for Nikon SLR digicams, which are based on Nikon's popular F-model SLRs.

The point of selecting the aperture first, and then accepting the exposure that the camera deems necessary, is that there are certain situations in which a different aperture will change the picture in a desirable manner. This

Figure 117 The left-hand photograph was taken with an aperture of f1.4, and the right-hand photograph with an aperture of f16, in both cases focusing on the nearest chessman.

area of photography is concerned with depth of field. When a lens is focused on an object near to it, the object will appear sharp in the photograph. Objects that are quite near to the subject, but a little closer to, or further away from, the camera, will appear sharp, too. Objects that are

is at the largest aperture, while, conversely, the largest depth of field is at the smallest aperture.

The ability to change aperture is very useful in two ways. Firstly, if you want to isolate a subject from its background, focus sharply on the subject (and if you are taking a photograph of a person or animal, focus on the eyes) and then, using aperture priority, open up the lens as wide as you can. To throw the background out of focus and concentrate attention on the subject, also use aperture priority and select a large aperture. 'Large' means a large lens opening, which means a small 'f' number or stop (see Chapter 8, pages 156 to 159): f4 is a smaller number than f8, for example, making f4 a larger lens opening or stop than f8.

further away will seem less sharp, however. The area that is reasonably sharp is referred to as the 'field', and is referred to in 'depth-of-field' tables, which, along with the depth-of-field markings that appear on some lenses, are based on technical definitions of what is sharp and what is not. If you open up the lens to a large aperture, the depth of field will shrink and the picture may only be sharp over a narrow zone. At a small aperture, the depth of field is at its maximum. In other words, the smallest depth of field

Secondly, you can exploit the same effect in reverse by giving yourself the best depth of field possible, and the sharpest image from the nearest point to the lens to the far distance (called 'infinity' in photography, although, in practice, infinity starts no further away

Figure 118 When taking a photograph of an animal (even if it takes the form of a little silver charm) or person, focus on the eyes.

than perhaps 50 feet, or 15 metres, from any lens). You can do this by selecting the smallest lens opening, or largest 'f' number, which will always be at least f16, sometimes f22, and occasionally more. This is standard practice in macro-photography, in which very small objects fill the viewfinder and frame.

Look at the chessboard photographs in Figure 117. The photograph on the left was taken with an aperture of f1.4, a large aperture, and only one chessman is sharp, while the photograph on the right was taken with an aperture of f16, a small aperture, and all of the chessmen are sharp.

Whether you select a large or small aperture setting, you will need to take the exposure time into account. Rather like windows whose curtains have been opened, lots of light gets through lenses that have been opened wide, which means short exposure times. Little light gets through small apertures, or lens openings (similar to drawing back thick curtains a little to let in a chink of light), however, which means longer, and maybe very long, exposures. In this instance, ask yourself if you could hold your camera still for long enough. (The left-hand chessboard picture in Figure 117

Figure 119 This photograph was deliberately blurred to give the impression of speed. The effect was created by selecting a small aperture (f25), leading to a slow shutter speed (1/25th of a second), and then panning the camera to follow the car to incorporate extra blurriness into the background. The effect would have looked even more impressive had the car been a Ferrari or an Aston Martin, but the cameraman got tired of waiting for such a rarity to come along.

needed only 1/200th of a second at f1.4, which presented no problem, but a steadying tripod was necessary for the picture on the right, which required half a second at f16.)

It is the automatic-exposure control that adjusts the shutter speed in accordance with the lens aperture that has been selected. SLR digicams that have a display panel, or display information in the viewfinder, along with a few other digicams, will tell you what the shutter speed will be for the aperture that you have chosen, but less complex cameras will adjust the shutter speed without telling you what it is. Some cameras will at least display a warning saying 'Danger, risk of camera shake', or words to that effect, a signal that may be generated by the choice of lens or zoom position (the risk of camera shake is exactly the same when you use a zoom at its maximum extent as when using an interchangeable-lens camera with a similar lens). At the time of writing, Olympus announced the launch of an SLR-type digicam with a built-in 'anti-shake' feature at a relatively reasonable price. Because 'VR' ('vibration resistance', as Nikon calls it) is also a costly feature of new Nikon lenses, it may be that this technology, which has been around for years and is used for binoculars and highly expensive lenses for professional cameras, will soon become more readily available to ordinary camera-users.

Aperture priority can also be used when you are not concerned about the depth of field, but want the shortest possible exposure time in order to 'freeze' a motion, or else want a long exposure time because blurriness would give the impression of speed. This brings us to the shutter-priority feature.

SHUTTER PRIORITY

When manufacturers build aperture-priority control into their digicams, they also include the shutter-priority feature. You should select this feature when you are most concerned with shutter speed, perhaps because you want either to freeze or blur a motion when photographing sports or a waterfall. (But note that waterfalls are difficult subjects: too short an exposure will make it appear as though the water is frozen, while too long an exposure will make it look unreal. Try bracing the camera or using a tripod and starting with 1/25th of a second.)

Figure 120 A shot taken at 1/100th of a second.

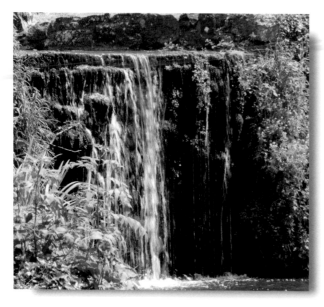

Figure 121 A shot taken at 1/60th of a second.

Figure 122 A shot taken at 1/20th of a second.

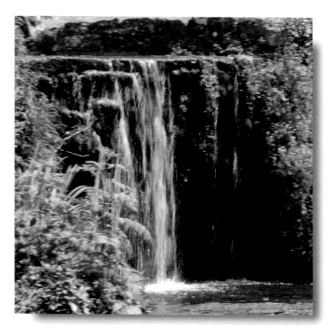

Figures 120 to 122 show three shots of the same waterfall, taken at 1/100th of a second (Figure 120), 1/60th of a second (Figure 121) and 1/20th of a second (Figure 22). Note how the appearance of the water changes. Had the exposure been any slower, the result would have been the kind of continuous-foam stream that is so unrealistic and spoils many shots of waterfalls. But had the exposure been so short that the water seemed frozen and showed no motion at all, the effect would have been equally unbelievable.

Shutter priority is selected and controlled in a similar way to aperture priority (see above). When the camera is pointed at a subject and the exposure is assessed, the lens opening will change as necessary, but the shutter speed will remain fixed, with the LCD screen reflecting the settings. Select a high or fast number for a fast shutter speed to freeze motion, and a low or slow one to make it blurry. (Remember that although blur can be deliberately used to create an artistic effect or to improve a dull shot, the viewer must be able to interpret the blur for what it is, and not think that the picture is out of focus! It is therefore usually, but not invariably, best to ensure that the picture contains something in sharp focus to contrast with the blurred part.)

The photographs shown in figures 123 and 124 demonstrate that although software can create certain effects, they will not be the same – and perhaps not as good – as those produced by using the camera controls properly. And you will probably already have realised that selecting either shutter or aperture priority can produce identical results, the only difference being that selecting shutter priority will allow you to put a precise number on the value that you have selected. Do you want a fast speed with which to freeze movement? If so, select 'aperture', set it to maximum, and the camera will tell you what speed it is able to use. If you select 'shutter' and choose 1/1,000th of a second, for example, this may either be accepted or may trigger an error message saying that the picture will be underexposed

Figure 123 Although this is the same photograph as that shown in Figure 124, it was subsequently blurred in an attempt to give the impression of speed. Unlike the photograph of the speeding car shown in Figure 119, for which a slow shutter speed was used and the camera panned, this image was reasonably sharp before it was subjected to software treatment, 'motion blur' being added in Photoshop. You should draw your own conclusions as to which is the more effective way of getting the desired result.

Figure 124 The original version of the photograph shown in Figure 123 is a 'straight' picture, and as sharp as possible. Exposure data: 1/750th of a second at f7.1.

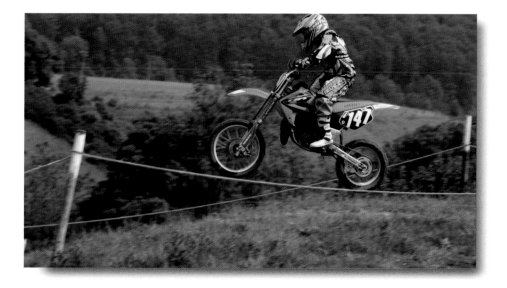

Figure 125 This carefully thought-out shot was taken for a competition in which photographers were invited to submit a picture entitled 'Clever stuff'. Trying to capture a speeding motocross rider in mid-air was difficult enough, and getting the rider at just the height so that it appeared as though both wheels were on a rope, as though the rider were performing a circus high-wire act, was pretty lucky. Lying on the ground, pointing the camera at the right angle, turning off the auto-focus and using burst mode to take three or four shots at a time resulted in this photograph, one of a hundred others that were not right in some way.

and that you should therefore choose a smaller number; conversely, it may be accepted, but you could have used an even faster speed (if the camera provides it).

Shutter priority can go hand in hand with motorised shooting, especially in sports photography, when you hold down the button and let the camera fire away to take two or three shots, or even more. An SLR user who is used to a motorised unit may expect to be able to fire a dozen shots in rapid succession in the hope that one will catch a goal-keeper at full stretch or a

Figure 126 This series of shots was taken in 'burst mode' – with the shutter-release button being held down for two seconds to take three frames per second – in the hope of getting a good shot of the fast-moving dancers.

cricket ball being caught or dropped, for instance, but there are extra factors involved in digital photography.

When the shutter-release button is pressed, the image goes into the buffer (which is rather like random-access memory, or RAM, in a computer), where it is processed before being transferred to the memory. The buffer has a finite capacity, so that if you are using maximum file sizes when shooting photographs, the camera may be unable to take more than a few frames before it needs to 'rest' while the buffer is unloaded, which can take as long as ten seconds, and longer in cold weather. This is one of the few differences between the various versions of Nikon's D1 cameras: one model will take three frames per second for up to nine shots at full file size, for example, but another will take a remarkable five frames per second for up to forty shots at full file size (albeit at a file size of only 3 megapixels, although this is only 'small' in relation to the 6 megapixels that other versions offer). If this feature is important to you as it is to many professional sports photographers this may be the one for you: but you will need to study camera specifications very closely.

Another, more minor, factor to take into consideration is the time that it takes the auto-focus to work, irrespective of file size. In some compact digicams, the time-lag between pressing the shutter release and the camera responding can be measured in seconds. If you are into sports photography, such a camera would be unsuitable for you, so either try out your chosen camera in the shop before buying it or remember to pre-focus and then switch to manual (as was done before taking the photograph shown in Figure 125). In fact, if you require your camera to shoot rapidly, choosing the right camera and testing its capabilities will be time well spent – before and after making your purchase – in order to learn more about it and become really familiar with both it and its limitations, which you will either have to work with or find a way around.

chapter 8

MORE ABOUT EXPOSURE CONTROL

MORE ABOUT
EXPOSURE CONTROL

Exposure control is automatic in digicams, unless manual mode is both available and selected. Using either the aperture- or shutter-priority setting alters this, which means that after selecting an aperture of f8, for example, the automatic exposure control will select the right shutter speed. If you want to set both the shutter speed and aperture yourself, you will need to use manual mode. The usual range of 'f' stops (see below) and shutter speeds – f8 and f11, and 1/30th or 1/60th of a second, for instance – that are referred to in this area of photography are left over from the days when cameras had entirely mechanical arrangements. Today's electronics enable the camera to select any 'f' stop that is required, like f7.7, and such speeds as 1/36th of a second, to give very precisely calculated exposures, far more so than when you could only choose the nearest value to the one that you really wanted.

However, when you switch to a priority mode, the camera reverts to the old system of rounded-up or rounded-down numbers. The camera decides the actual value by measuring the light somewhere on the image's area, the exact point being a matter of some importance. The more complex digicams, which are capable of producing the best pictures, especially in tricky conditions, sometimes offer a choice, which is usually between matrix-metering and spot-metering.

Figure 127 This winter landscape is an example of a high-contrast subject.

SPOT-METERING
AND MATRIX-METERING

When there is a significant contrast between a sunlit area and deep shadow, for example, spot-metering may be used, in which the spot is positioned on an intermediate tone (chose a green not in shadow if possible) to avoid the exposure being overly influenced by a large area of shadow, the user then moving the camera slightly to obtain the required view. The shutter-release button is usually half-depressed to lock the exposure value before repositioning, although some cameras have an extra button for this purpose.

Matrix-metering means taking readings at a number of points and then using them all to work out the required exposure. Most of the simpler digicams make this kind of assessment because it generally gives the best results in average conditions. The built-in

software will sometimes make compensations that the camera-user cannot influence, however: it may be that the values at the top of the image (often the sky) are given less importance, for instance, or that extreme readings are disregarded so as not to skew the average value. Matrix-metering works well for most shots, but not for all, such as when an important element of the image is large and has an extreme exposure requirement.

When there is an extreme difference between light and shade, matrix-metering can be overly influenced by these extremes, resulting in the images shown in Figure 128, for example, with either the external view being properly exposed and the wall being too dark (the left-hand photograph), or the wall being correctly exposed, but the outside view through the window being

Figure 128 Two views through a grille. The combination of outdoor and indoor light always involves a tricky exposure assessment.

burnt-out (above right). After some experimentation, the picture on the left turned out to be the best that could be achieved using automatic assessment. The better picture, that on the right, was taken using an exposure reading from the illuminated part of the window to capture the exterior light correctly and then adding a fill-in flash to illuminate the interior and pick up the subtleties in the lichen on the stone. Spot-metering was used to take the window reading for this photograph. The spot is usually taken from a specific place in the image, and usually a point at the centre, although some digicams give the user a choice. Getting the best-possible exposure is

Figure 129 'Display' having been switched on, this LCD screen shows the camera's settings. Spot-metering has been selected, and the cross in the centre of the screen is the focusing spot. The other information being displayed is, from left to right, top line: the battery state; the remaining running time before recharging becomes necessary; the file size (2,048 as the pixel count in the larger dimension of a 3 megapixel file); and the number of exposures on the memory card, but note that some cameras display the number of exposures remaining rather than taken. The second line displays the spot-metering symbol and the focusing-mode symbol, an icon of a flower, which indicates that macro has been selected.

the basis of getting the best-possible picture in technical terms, so familiarise yourself with the options your camera offers.

A great advantage of digital photography is the ability to check the results of the selected settings on the LCD screen, so that if the image doesn't look right, you can experiment and then delete the unsuccessful pictures. An extremely complex digicam, such as an SLR, offers far more features and choices than can

possibly be instantly absorbed, so make sure that you read your instruction book regularly because you may be surprised to find that you'd forgotten that the

camera offers a useful feature. And the better you know your camera, the less time it will take to experiment, and the quicker you will get a good shot.

Figure 130 A digicam's top-mounted display window. The information provided includes the file size, the saving format, the number of exposures remaining, the white-light balance setting, and the focus, or exposure, spot in relation to the viewfinder, indicated by the red arrow. In this particular camera, the spot can be moved around the screen, from the usual central position to the 3 o'clock position shown here,

or else to 6, 9 or 12 o'clock. It may be simpler to position the critical focus at a desired point in this way, thus ensuring that the focus and exposure remain set at the selected values, rather than using the usual alternative of locating the centre of the viewfinder on the critical area and trying to depress the shutter-release button halfway down while repositioning the camera to capture the desired view.

'STOP' OR 'F' NUMBERS

At this point, it may be helpful to delve into the history and meaning of the expression 'stops'. 'Aperture' (the word means 'opening') initially referred to the diameter of a lens, and early experimenters found it useful to fit a variable ring to the lens that could be contracted or expanded (rather like the iris in the human eye) to restrict or enlarge the lens' opening. The iris ring being mechanical, a number of click-stop positions were incorporated to restrict its movement, or to stop it at particular points, each position being mathematically selected so that the area of the lens that is open is half of what it is at the next position, starting with ½ , then ¼ , and so on. But because these figures are easily confused with shutter speeds (which are quoted in fractions of a second and, in the early days of photography, exposures of ½ and ¼ of a second were common because film was of a low sensitivity), they were instead given aperture numbers, also called 'stop' or 'f' numbers, each of which expresses the opening diameter relative to the focal length. If the lens is 1 in. (2.5 cm) in diameter and the focal length is the same with the iris fully open, this is equivalent to a stop number of f1 (because the ratio is 1:1). If the lens is only ½ in. (1.25 cm) in diameter, or the iris ring is closed so that only the central, ½ in.-diameter, part lets light through, the ratio is 1:½ or 1:2 because the focal length remains the same, so that the f number is f2. In other words, the focal length is twice the effective diameter. (Actually, f1 is unknown – in the early days of photography f8 was about the largest seen.)

In conventional photography, the

24ᵐᵐ F1.8 EX DG ASPHERICAL MACRO

Figure 131 The Sigma 24 mm (top) and 28 mm (bottom) f1.8 lenses. Although very wide apertures and long focal lengths do not work well together, because of the enormous diameter of the lens and cost and weight, they are a feasible combination in wide-angle lenses. Used on an interchangeable-lens SLR, these two lenses would be equivalent to a wide-angle and almost normal-angle lens respectively, and would give a two-stop advantage over an average zoom lens. One or both may therefore be a worthwhile investment if you are interested in low-light photography.

28ᵐᵐ F1.8 EX DG ASPHERICAL MACRO

maximum lens aperture was once one of the most important aspects of a camera's design (in the days when colour film, such as the 10 ISO Kodachrome 1, was extremely slow), and manufacturers competed to produce ever wider lenses, even as wide as f1.1. Today, with fast films being the norm in conventional photography, and digicams having extremely high sensitivity equivalents, it is not so important, which is why lenses wider than f2.8 are unusual. It can still be very useful, however, and if you want a lens that is wider than f2, you would probably have to buy an SLR to be able

Figure 132 Big boys' toys. The exposure for this photograph was automatically set at 200 ISO and 1/400th of a second at f7.1, using a 28–80 mm zoom at 31 mm, or 46 mm after the multiplier effect had been allowed for. The exposure for shots like this is best left to even the simplest digicam to calculate.

to take advantage of such lenses as the f1.8 Sigmas shown in Figure 131.

'F' numbers are arranged in a rather odd-looking series, ranging from f2.8 to f4, and then to f5.6 and f8. Why not f2, f4 and f8? Because each of the series lets in twice as much light as the last on account of the area of glass being doubled, not the diameter. The importance of this, photographically speaking, is that twice the area lets in twice the light, giving twice the exposure, unless the shutter speed is changed accordingly. Counting in the opposite direction, the usual series ranges from f32 through f22, f16, f11, f8, f5.6, f4, f2.8, f2 and f1.4 down to f1.1, although lenses that open much wider than f2.8 have never been common because they are so costly. Another, interpolated, series includes f6.3 between f5.6 and f8, and f12.5 between f11 and f16 and so on, the actual numbers depending on the starting point.

Do not be confused if the stop numbers that are displayed on your digicam's LCD screen look quite different to those described above. This is because a digicam's electronics are not restricted by the limitations of mechanical settings or complementary shutter speeds. Whereas the only settings available to a mechanical camera are, for example, 1/60th of a second at f8, f5.6 or f11, or, alternatively, 1/30th or 1/125th of a second, your digicam can select 1/85th of a second at f7.7, for instance, to give a much more precisely calculated exposure.

BRACKETING AND COMPENSATION

Although it may seem strange that digicams provide these functions when their exposure control is so precise and you can check the effects, bracketing and exposure compensation offer a good way of taking several shots at once before looking at the results.

Bracketing means taking several shots using the calculated exposure, whatever that may be, as well as one or more shots at a different exposure or exposures at the same time. A bracket could be one shot at, perhaps, one stop more than the figure calculated, and one shot at one stop less, the brackets being on both sides. The term is also extended to cover a situation in which the bracket is two, three, or four shots (if the camera allows that many), all at different exposures. Photographs may therefore be taken at one, two and three stops under- or over-exposed, as well as at the calculated exposure. The extent of the difference between two exposures can usually be set to one- or two-thirds of a stop or to whole stops. Bracketing is combined with a 'multi-shot' facility in which you hold down the shutter-release button as the camera fires away.

Bracketing is a great way of rapidly arriving at an understanding of an area in which you are working that has difficult lighting. Bracketed shots are also useful when working with flash exposure (if the camera allows it, in which case consult its handbook for further details).

Exposure compensation, which is more often provided in digicams than bracketing, is effectively the same process, but without the bracket, in that it takes shots at plus or minus stops relative to the calculated exposure as single shots, instead of

Figure 133 Two of the most difficult exposures to calculate are for white-and-white and black-and-white subjects, and bracketing would be a great time-saver when trying to work out the correct settings. These shots were taken without using bracketing, but it would have been better to have used a slightly different exposure to give the white flowers more detail.

using the multi-shot effect required for bracketing. What is the difference? It's principally a matter of ease of usage: if you set a bracket, you can hold down the shutter-release button and take three or four shots one after the other, with the camera doing all of the work, but if you cannot set a bracket, you need to perform several menu operations to reset the controls between each two shots.

Whether you have been using bracketing or exposure compensation, do not forget to reset the camera to its normal settings afterwards. Some cameras have a 'two-button resets' control, which means that when you press two particular controls at the same time and hold them for a second, all values are reset to the normal, default setting, which is useful if you have been experimenting.

CONTRAST CONTROL

Figure 134 shows a scene that was photographed using a digicam's low-contrast setting, which is useful for portraiture and photographs for which a high degree of contrast would be undesirable. It is unsuitable for landscapes, however. The photograph shown in Figure 135 was taken using the normal, default setting, resulting in an image that is better, but still not good enough. The photograph shown in Figure 136 was taken using a higher-contrast setting, and looks much punchier and more interesting. Although the same effects can be obtained using software manipulation, it is always advisable to take the best picture you can rather than relying on being able to improve it later.

Flat lighting can produce boring pictures, but hard lighting can result in

Figure 134 This photograph was taken using a low-contrast setting.

Figure 135 This photograph was taken using a normal-contrast setting.

Figure 136 This photograph was taken using a high-contrast setting.

pictures that contain too much contrast. Those conventional photographers who did their own dark-room work used different 'grades' of printing paper to control contrast, and in the days when photography meant monochrome, or black-and-white, pictures, they used the expression 'soot and whitewash' to describe a picture that contained too much contrast. The effect can be seen in colour pictures whose shadows are too dense and dark to show any detail, and whose highlights are so light ('burnt out') that the detail is again lost.

Contrast can be expressed mathematically as a ratio between the lightest and darkest parts of an image, too much contrast simply being a ratio that is higher than the medium can handle. Many digital cameras now offer different contrast settings, and if your camera has an adjustment for contrast, you should generally leave it in the 'normal' position until you start to understand digital photography really well, when you may want to change to a different setting. If you decide that your photographs look a bit flat, for example, try using more contrast, or vice versa if they look as though they contain too much contrast.

If your digicam does not allow you to adjust the contrast, note that you can do it later using computer software (but remember that the best pictures are those that started off looking the best in the camera). You may also find it useful to know that many sophisticated compact cameras allow you to adjust the contrast by switching to landscape or portrait mode, even if you aren't photographing a landscape or portrait.

FLASH

Most cameras have an in-built flash, while the anti-red-eye feature, which prevents subjects' eyes from appearing red in photographs, also generally comes as standard.

One of the most important, and underused, possibilities of flash is to

Figure 137 This picture was taken with a very simple camera, without flash. Automatic exposure adjustment had to be used because this feature could not be turned off and there was no aperture- or shutter-priority control, nor any choice regarding taking exposure readings. The brightly lit wall and shadowy bronze horse created a difficult situation that this photograph did not satisfactorily resolve.

Figure 138 This photograph was taken from the same spot as that in Figure 137, but using fill-in flash. It is a better picture because the bronze and flesh tones are more visible. The background wall is now over-exposed, but as the subject is not the wall, that is not really a problem.

fill in shadows and improve the brightness and interest of a picture without using too much contrast, and experienced photographers often use flash – even when photographing landscapes – to brighten foreground features. It is, however, useless to try to lighten mountains in the distance using flash because the flash behaves like a cone of light, spreading out as it widens, so that in this instance it will be spread too thinly to be of any value. So note that flash only works at close distances, and remember the 'flash distance' given in your digicam's instruction book, because the flash will not be powerful enough to illuminate much beyond that.

Figure 139 The left-hand photograph shows a digicam's flash hot-shoe. Note the three contact spots that match up with those on a flash gun, enabling the camera to control the flash duration. This gives much more control over flash than using built-in flash because it allows diffuser screens, half-power flashes, larger, and more powerful, flashes and so on to be used. It also enables the flash gun to be mounted at a distance from the camera via a cable, such as the one shown in the right-hand photograph (the flash gun is plugged into a hot-shoe on the cable, while the other end of the cable is plugged into the camera's hot-shoe). A remote flash gun enables the gun to be held high, or on one side, giving a more flattering light.

True SLR digicams usually have a pop-up flash device over the viewfinder's eyepiece, but if you are considering buying one of these cameras, it is really worth looking out for one that provides a hot-shoe (see the left-hand photograph in Figure 139), two brackets that allow a flash gun to be attached to the camera and include the necessary contacts that enable the flash synchronisation to work. SLR and SLR-type digicams are usually equipped with hot-shoes, while some of the better compacts have a socket for a flash plug, which gives the same results via a different connection point, to which you could connect a proprietary flash gun (and note that the worst possible position for a flash is on a camera).

chapter 9

DIGITAL PHOTOGRAPHY WITHOUT A CAMERA

DIGITAL PHOTOGRAPHY WITHOUT A CAMERA

Like many people, you probably have a stock of old photos – be they prints, slides or negatives – from which you may want to make new prints. It may be that you are interested in printing your own using a personal computer and colour printer, for instance, or perhaps you'd like to compile an album of both recent and 'historical' pictures to present as a slide show on your computer's monitor screen. If, for example, you are putting together a pictorial history of your son's life for his twenty-first birthday, you could scan photographs of him as a baby in the bath to add to the slide show.

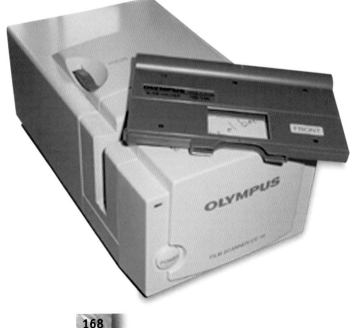

Figure 140 This Olympus scanner is designed to scan both slides (using the carrier shown here) and negatives (using a different carrier).

SCANNERS

Scanners enable you to turn old pictures into digital photographs, in the process also offering great scope for improving them. Some models automatically remove scratches and dust marks from negatives and slides and restore colour to faded old shots, for instance, and you can do even more with dedicated software, such as Adobe Photoshop.

There are three types of scanners. Firstly, flat-bed scanners, which are suitable for working from paper prints only; these are the cheapest scanners. Secondly, transparency and film-negative scanners, which are the most expensive (the most basic may cost the same as a mid-range digital camera). And thirdly, dual-purpose scanners, which scan prints, transparencies and negatives, whose cost depends on their complexity. A middle-of-the-road dual-

purpose scanner is probably capable of scanning a print or four slides simultaneously, for example, while a top-of-the-range model can handle perhaps twelve slides at once.

Using a dual-purpose scanner

The dual-purpose scanner shown in figures 141 and 142 has a reflective white panel in the cover that is used when scanning prints, but which can be removed to reveal a lamp that shines through any transparencies or negatives when a carrier containing them is placed on the scanner's glass bed. Your scanner (and software) may follow a slightly different procedure to the one shown, which is the Epson Perfection Photo 1650 that I am using as an example, but you may nevertheless find the following step-by-step explanation useful.

1 Before the Epson Perfection Photo 1650 scanner can be used, the appropriate software provided with the machine must be installed on your computer and the scanner connected both to the computer and power supply (the software should usually be installed first and the scanner connected to the computer last). This model has no on/off switch, which means that plugging it into a mains power supply will turn it on. When you open the lid, the glass screen is revealed. This must be kept scrupulously clean because any specks of dust or scratches will cause imperfections in the scanned image. (Even if the software includes a 'dust-removal' facility with which to remove white spots from images, it is far better simply to remove the dust in the first place.)

2 If you are planning to scan a print, place it face downwards on the glass screen and close the cover (Figure 141). If you are intending to scan some transparencies, first remove the white reflective screen from the scanner's cover to expose the lamp,

Figure 141 A print has been placed face downwards on a flat-bed scanner's glass screen. Note the white reflective screen inside the cover.

and ensure that none of the transparencies have glass mounts, which may create unwanted reflections. Now place the transparencies horizontally in the appropriate carrier (don't worry if the images are facing in the wrong direction because this can be corrected later), with the emulsion side facing downwards (which usually means that the dark side of the mount is facing upwards), and close the cover.

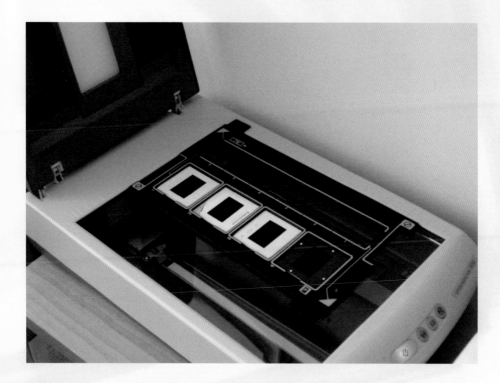

Figure 142 The white reflective screen has been removed to enable the lamp in the cover to shine through some transparencies. The transparencies have been loaded into a carrier with the emulsion side facing downwards; the carrier will hold them in position beneath the lamp once the cover has been closed.

3 Whether you are scanning a print or transparencies, the procedure is now essentially the same, except where indicated. Using your computer, open the scanner software, in this case Epson Smart Panel, and click on 'Scan to Application' (not 'Scan to File'); see Figure 143. The Twain panel (the name of the scanning programme) will now appear and the scanner may start scanning on an automatic setting, which may be the wrong one. If so, click on the 'Cancel' button as soon as the 'Pre-scanning' drop-down window (see Figure 144) will accept an instruction, which is usually only when the pre-scanning operation is in progress. Clicking on 'Cancel' will take

you into manual mode, and the Twain window will now reappear (if you are running Windows XP, possibly showing the wrong configuration; see Figure 145 for details on how to correct it).

Figure 143 Epson Smart Panel's opening screen; the white arrows are pointing at two controls. If you are scanning transparencies (35 mm film transparencies, for example) to make digital images, it is best to scan to file so that you end up with a master file on your hard disc to experiment with. If you only want a single print, however, choose 'Photo Print'.

Pre-scanning in Progress

0 %

Cancel

Figure 144 The Twain panel's 'Pre-scanning' drop-down window.

Figure 145 This Twain window shows the print, not multiple-transparency, screen, and thus the wrong pre-scanning setting for this particular job (it is, however, the correct setting if you are scanning a single print). The controls that should be reset before scanning multiple transparencies are highlighted with arrows: 'Flatbed' should be changed to 'TPU' (an acronym for the transparency or slide carrier)]; 'Illustration' should be changed to 'Colour positive' (in accordance with a normal transparency); 'OCR' (which stands for optical character reader or recognition) should be changed to your preferred destination; and you may also want to reset the resolution. Make all of these changes by selecting the correct setting from the appropriate drop-down menu.

4 Set the resolution as high as you can – the higher the better in terms of image quality – but note that because the scans go into RAM, and better-quality images mean larger files, you may receive a message indicating that there is insufficient memory if you try to scan four transparencies at once at too high a setting. If there is a limitation somewhere in the system, try to set the resolution at least twice as high as you need. If your printer prints at 300 dpi and it is prints that you want, for example, set the resolution to 600, but if your printer prints at only 72 dpi, 150 dpi would be high enough. If you require an image for a screen, however, you will need a high-dpi file, even if your monitor is set at 72 dpi. In summary, it is best to use a high resolution, such as 400, to start with, even if you subsequently intend to reduce the file size. (Experimenting with various settings to ascertain the differences between the final versions will save you time when carrying out future scanning operations.)

5 If the image is to be projected, set the right-hand box in 'Source' to 'pixels' and move the slider under 'Scale' until the pixel setting is just less than that of the screen. For an SVGA screen, for instance, the maximum pixel setting for the target image could be, perhaps, 1024 x 768, giving a file size of 1.80 MB when scanned at 1,600 dpi.

6 If you are interested in printing a picture file, set the right-hand box in 'Source' to 'inches' (or centimetres, if you prefer), then set 'Target' to inches (or centimetres), decrease the resolution to, perhaps, 150 for a 72 dpi-printer setting, and move the slider under 'Scale' to a little higher than the size of the largest print that you require (16 x 9 in. if you want the occasional A4 print, for instance, There is little point in making it larger unless you have an A3 printer). See Figure 146 for a sample window. Note that the volume or file size , shown here as 5.59 MB, will vary according to the resolution and dimensions that have been set. Reduce or increase the size using the slider (indicated here with a green plus sign), remembering that you will need a large file for your hard disc,

Figure 146 The correct Twain window for printing out four transparencies after they have been pre-scanned.

and can always reduce it later. If the transparencies are upside down or need to be rotated, use the 'E' buttons (highlighted in yellow), but note that most manipulation software programmes will enable you to do this later. Click on 'Scan' (highlighted in yellow) to make full scans of the

transparencies, one after the other. When you have finished, click on 'Close' (highlighted in yellow).

Figure 147 'Finish' window.

Figure 148 Nearly done!

7 A new window will now appear, as illustrated in Figure 147. If you want, you could rename your files here (as indicated by the arrow in the top left-hand corner) to make them easier to locate later, but if you click on 'Finish', do not worry about where to find them because the next window (see Figure 148) will deal with that. Note that it is best to finish and restart before scanning more images to avoid the risk of losing those that you have just completed.

8 Save each file in a specific location by browsing and navigating your way to it in the usual way. The drop-down menu indicated with a horizontal arrow in Figure 148 enables you to change the file format, and you can make the file smaller or larger in size by using the slider indicated by the vertical arrow. Larger files make better prints and images, although they take up more disk space. It is best to save a large file to start with as you can always reduce its size later on, but you can't go back up. When you have finished, click on 'Save' (highlighted in yellow), and then on 'Finish' in the final menu (not illustrated).

9 A further window may now appear showing all of the image-handling applications that have been installed on the computer. You can either access one of these, open each file and carry out further operations, or else close the application and maybe access the files in another way.

More scanning tips

The time that it takes to work through the whole step-by-step scanning procedure described above depends on a number of factors, but if the images are named and saved in different files, four transparencies may take fifteen minutes to digitise, which may be worth your time if the shots are important, but may be a daunting prospect if you are considering archiving ten years' worth of holiday transparencies. (And don't throw away your old slide projector yet because you will need it to enable you to look at your old transparencies to decide if they are worth digitising.) Although you could always have your images scanned and saved to CD at a photo shop, note that this will be a far more

Figure 149 The arrow indicates the 'Automate' command in Photoshop. (The 'Batch' command appears in the menu after 'Automate' has been selected.)

expensive option than doing it yourself.

If your stockpile of old images includes prints and their corresponding film-strip negatives, note that it may be worth working from the negatives rather than the prints: not only will the negatives be less faded than the prints, but you can set your scanner to recognise colour negative film and make the appropriate allowances or corrections. Many of the better scanners have scratch-reducing and dust-removing facilities, too, enabling you to improve the quality of old images (which you can also do using image-manipulation software programmes).

Finally, if you have not been deterred by the time that the process will take and decide to digitise a large number of images, remember that the 'Automate'/'Batch' commands in software programmes like Adobe's Photoshop can simplify and speed up the task of performing the same sequence of operations when working with a series of images. These facilities are only worth using in the final stages of the process, however, that is, for naming files and so on after the images have been scanned.

chapter 10

DOWNLOADING, LABELLING AND VIEWING IMAGES

DOWNLOADING, LABELLING AND VIEWING IMAGES

Whatever you are going to do with them, be it having prints made or making them yourself, e-mailing them or posting them on a website, downloading images onto your computer is a very useful thing to do, simply because you can either keep them on your hard drive or burn them onto a CD for future use. Do this, and there'll be no more hunting for envelopes containing old prints and negatives, only to find that they've been lost or damaged. And when they are stored in 'My Pictures', perhaps within subject folders, on your hard drive, you can view thumbnails (pictures the size of a postage stamp) of all of the images and rapidly flick through them until you reach the one that you want.

The freedom that digital photography gives you to be trigger-happy and shoot far more pictures than you ever did when you had to buy film and pay for every shot to be developed can lead to a plethora of pictures that are difficult to keep track of. There are many software programmes that can help you to organise and store your picture files, however, many of which are regularly given away with photographic magazines, while others, such as Adobe Photoshop Album, can be purchased quite cheaply. In Adobe Photoshop Album, for example, you can open your files in a window, apply tags to them, such as 'family', 'friends' and so on, and later ask the programme to find all of the files that have been labelled with a particular tag. This is just one of the features offered by Adobe Photoshop Album's rich menu of image-sorting, image-filing and image-logging capabilities.

Figure 173 The file-tagging function in Adobe
Photoshop Album.

DOWNLOADING,
IMAGES

There are several ways of downloading images onto a computer, depending on the type of digicam. In other words, you can only download images from a camera directly onto a computer using a universal serial bus (USB) cable, but no software, for instance, if both your camera and computer support this procedure. All of the newest digicams are capable of direct downloading, but none of the oldest designs are, and of those in between, some are, and some

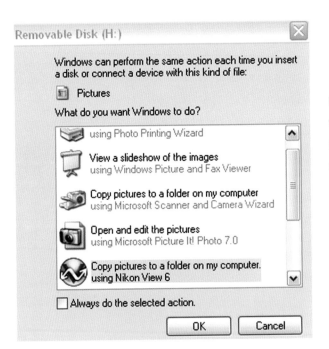

Figure 174 The appearance of this window on the monitor screen confirms that Windows XP recognises the camera.

Figure 175 The 'Nikon Transfer' window.

Figure 176 This window shows the progress of the downloading procedure.

are not. (If you are considering buying a secondhand digicam, check that it comes with its original cable because nearly all digicam models seem to require different plugs, and you may find it difficult to find a suitable replacement cable.)

If your camera cannot download images directly, however, you can remove its memory card (and only the simplest cameras have a fixed internal card) and insert it into a card-reader connected

either to your computer or to an external storage device (see pages 188 and 248 to 249 below) as long as the appropriate port is available.

If Windows XP and a graphics card (and a graphics card is required if your computer is to handle any images at all) have been installed on your computer, switching off your digicam, connecting it to the computer via an appropriate cable and then switching it on will trigger the appearance on the

183

Figure 177 The 'Nikon Browser' opening window.

Figure 178 Large thumbnails.

Figure 179 An image's shooting data displayed in the 'Nikon Viewer' window.

Figure 180 Microsoft Picture It! 7.0 (provided in Windows XP 'Home') can be used to locate picture files.

Figure 181 You can connect a card-reader to a computer by plugging it into the computer's parallel port (for which the connection shown on the right is suitable) or USB port.

monitor screen of the window shown in Figure 174, which displays all of the image-handling applications on the hard disc.

In this case, Nikon View 6 (a browser), indicated by the greyed area in Figure 174, was selected, resulting in the appearance of the window shown in Figure 175. Click on the yellow button to start the transfer process (Figure 176 shows its progress). (The application can be set to delete the images from the camera as they are downloaded, saving time later.)

Once the pictures have been downloaded, the 'Nikon Browser' window appears (see Figure 177 in this case), displaying all of the downloaded files as thumbnails, with the name of the folder to which they were transferred' greyed on the folder tree to the left.

Note that you can vary the size of the thumbnails by using the 'View' function (indicated by an arrow in Figure 178); the thumbnail shown earlier (in figure 177) is the smallest, and those shown in Figure 178 are the largest. If you highlight a single thumbnail and specify a larger size, the browser will also display the image's shooting data provided this is 'embedded' or 'tagged' as part of the complete file, as it is in many cameras (see Figure 179).

Although you may sometimes find viewing large thumbnails helpful, if you are searching for a picture in a folder that contains a large number of images, you may prefer to view lots of small thumbnails rather than scrolling through larger photos, Microsoft Picture It! can display a large number of images and the 'Browse' command in Adobe Photoshop fulfils the same function by filling the screen with postage stamp-sized images.

Figure 182 The Flash Path adapter is an alternative to a card-reader.

Card-readers and Flash Path adaptors

If you have a digicam that cannot be connected directly to your computer, you will probably still be able to download your images by using a card-reader (see Figure 181). Inexpensive and convenient, card-readers can usually be plugged into a computer's USB or sometimes one of the other ports, causing a pop-up message to appear on the monitor screen regarding a 'new device' (in early versions of Windows) or asking you what you want to do and offering alternative options (in Windows XP).

Although some card-readers will only work with a specific type of memory card – one with the Sony Memory Stick memory card, and another with the CompactMedia memory card and so on – others are multiple-type readers that will take most memory cards (and these latter card-readers are usually plugged into a computer's USB port exclusively, although the next generation will in all likelihood be wireless).

An alternative option is to use a Flash Path adaptor (see Figure 182), which resembles a 3½ in floppy disc. All that you need to do is to insert the memory card into the adaptor and then slot the adaptor into the PC's 'A' drive.

DSC_0001

LABELLING FILES
AND FOLDERS

The downloading process creates a new folder containing the images that you have downloaded, labelled as they were in the camera. If your camera enables you to do so, and you are an organised person, you may have given every image an individual name, in which case those names will appear in the folder. If you have left it to the camera to label the pictures, however, you will find that each download produces a new folder numbered, for example, 001, 002 and so on, perhaps with an 'IMG' prefix (which stands for 'image') or a prefix based on the manufacturer's initials (images from Sony digicams, for instance, are prefixed with the abbreviation 'DSC', which I presume stands for 'Digital Sony Camera').
It is best to change the folder's name to something distinctive and appropriate, such as 'Disneyland 15th

May' or 'Fred and Dora's party', immediately so that you do not have to open every picture folder on your computer when searching for a particular image in the future.

VIEWING PICTURE
FILES

Once the images have been downloaded, you can view them using the appropriate software, such as Microsoft Picture It!, which is provided with Windows XP. If you want to tweak your images a little to improve them, this also is a good place to start.

An alternative to programmes like Microsoft Picture It! is the software that many manufacturers provide with their digicams, There are many more programmes available to download from the Internet and Mac users may

consider GraphicConverter from Lemke Software.

Remember that if your computer set-up enables you to burn files onto a CD, you can view your images on a television screen (that is, if you have a suitable CD or DVD player, and many cameras are sold with basic dedicated CD players) or simply store them on CD to ensure that your hard disc remains uncluttered.

Figure 183 Microsoft Picture It! Photo 7.0's opening window.

CREATING OR IMPROVING IMAGES USING COMPUTER SOFTWARE

CREATING
TITLE SLIDES

If the term 'digital photography' is broadened to mean 'digital imaging', you will need neither a camera nor a scanner, but can instead create, or download, and manipulate images using your computer.

Digital imaging can be useful when making title slides for a slide show (see Chapter 12, pages 209 to 224), for

Figure 150 Adobe's ImageReady software programme can be used for making title slides.

example. And although it is not the only way of creating them, Adobe ImageReady is a good text-manipulation computer-software programme for making such title slides. (This programme is often bundled with Adobe Photoshop, and may also be available to download for a free evaluation, so look out for it.) One of its advantages is that it can be used to

Figure 151 A title slide that was made for a slide show using ImageReady, without working from an existing image. Clip-art images could also have been pasted into this file.

create a document from a blank 'canvas', enabling you to add text and images as though you were working in a word-processing programme like Microsoft Word, and to save the document in the JPEG format that is required if the file is to be handled by slide-show software. (The problem with working in word-processing programmes like Word is that you cannot save a file in the JPEG format, but if you save it in the BMP format, for instance, the slide-show software will not load it, and the file may not even be visible in the image-handling software.)

Creating a title slide in MGI PhotoSuite

MGI PhotoSuite, which was bundled with some Sony and Olympus cameras until recently (MGI has since been taken over, and any new software that the company issues may therefore appear under a different name), is another software programme that can be used to create title slides. Here's how.

1 To create a title slide in MGI Photosuite 8.1, first open the application. From the opening window (see Figure 153), select 'Get Photos', followed by 'Work on your Own' (both indicated by arrows in Figure 153).

Figure 152 A title slide made by adding text in MGI PhotoSuite 8.1.

Figure 153 MGI PhotoSuite's opening window.

Figure 154 MGI PhotoSuite's 'New Image' image-size menu.

2 Now select 'File'/'New'/'Image', and a menu offering you a choice of image sizes will appear (see Figure 154). Choose a pixel dimension that matches the image's requirements. If you are making a title slide for a slide show and want it to be both the same size as the other slides and to fill the screen, for instance, enter dimensions that match your screen. (Also note that smaller dimensions will certainly fit within the screen and may be sufficient if you do not intend to include much text with the image.)

3 Alternatively, select 'File'/'Open' and then navigate to the file that you want to use as a background image, as

illustrated in Figure 155. Now click on the 'Add text' button, 'A' (indicated by the arrow on the left in Figure 155) to bring up the 'Text' window. Select your preferred font, font style and size and then type your text in the text box (indicated by the second white arrow) and align it left, centre or right. When you have finished, click 'OK' to move the text to the image, where it will appear within a movable box (outlined with a dotted line as indicated by the arrow in Figure 156), which can be dragged and dropped into the desired position. You can repeat this process as often as you wish using different type styles, positions and so on, but note that the only available colour for the text is black.

Figure 155 A background image has been loaded into MGI PhotoSuite; the 'Add text' function and 'Text' box are indicated with arrows.

Figure 156 The title has been dropped into the desired position.

Figure 157 PhotoSuite enables you to experiment with the style and positioning of text.

4 When you are happy with the final result, do not forget to save the file in your preferred location, perhaps within a folder containing the slides for your slide show.

Figure 159 A title slide created in Adobe Photoshop Elements using the background slide that was featured in figures 155, 156 and 157. Photoshop Elements is a more versatile programme than MGI PhotoSuite, not least because it gives you the option of setting text vertically or horizontally and offers a wider selection of typefaces and colours.

Adobe Photoshop and Adobe Photoshop Elements

Adobe Photoshop, which costs a lot more than MGI PhotoSuite, is a more versatile programme, as is the relatively inexpensive Adobe Photoshop Elements (which may have been bundled with your camera, scanner or printer and, as its name suggests, contains many of Photoshop's elements).

Figure 158 Adobe Photoshop Elements' opening window.

5/6/03　　17:21

COLLECTING
IMAGES FOR
TITLE SLIDES

It is certainly worth taking a photograph of the sky or a field, for example, to tuck away in a folder ready for use as a background image for a poster or title slide. There may be occasions when you find that you possess no suitable images, however, in which case note that royalty-free images are available for downloading from the Internet for private use on personal websites and in slide shows (and do respect copyright conventions). Remember that the

picture file must have been saved in a format that is compatible with your computer software, such as JPEG, unless your software is able to convert it. Note, however, that most downloadable picture files are of a limited size, which in turn limits their quality.

PRINTING IMAGES

One of the easiest ways of viewing an image is to obtain a hard copy of it, and the simplest way of doing this, which requires no kit at all, is to take your camera to a photographic shop and have the image downloaded from either your camera or its memory card and then made into a print (and perhaps also transferred to a CD). Some photographic shops can correct images – just as you can on your computer if you have the appropriate software – for example, by making them lighter or darker, adjusting the contrast, sharpening the focus and so on.

The next step up from having your images printed by a photographic shop is to invest in a simple printer, perhaps with a docking station that enables your camera, or maybe its memory card, either to be fitted into an integral slot or connected to the

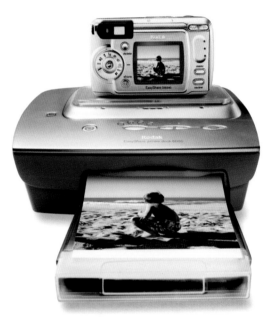

Figure 160 A combined Kodak printer and dock, with an EasyShare camera in place. There is no need for a computer when you can print directly from the camera like this.

printer with a cable and prints to be printed directly from it. Increasing numbers of cameras are being manufactured with this capability, and colour printers are amazingly cheap. Indeed, the simplest colour printers

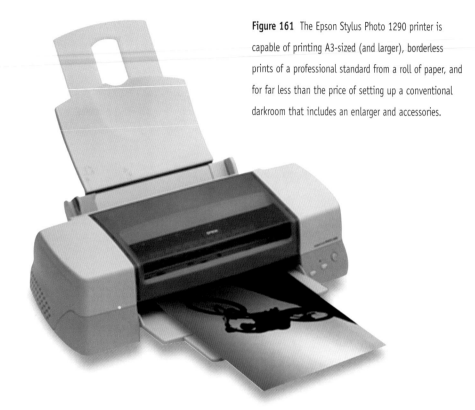

Figure 161 The Epson Stylus Photo 1290 printer is capable of printing A3-sized (and larger), borderless prints of a professional standard from a roll of paper, and for far less than the price of setting up a conventional darkroom that includes an enlarger and accessories.

cost less than almost any digicam, while a sophisticated, top-of-the-range, amateur model, maybe capable of making large prints (A3 size or bigger), can be bought for less than the price of a medium-range digicam.

If you have a computer, you probably already own a colour printer, rather than a specialised photo-printer, and inexpensive colour printers like the Lexmark Z65 and Canon Bubblejet 1450 are capable of producing good colour prints, as well as performing the usual range of basic home or office operations. Photo-printers give better results, however. Remember, too, that instead of just printing the image directly from the camera, you could improve it with a software programme, after which you could burn it onto a CD and either take it to a photographic

store to be printed or print it out yourself.

If you have a computer, but no suitable printer, you could download your images onto an appropriate website for printing, but note that the file sizes that can be handled in this way are limited, so that both the quality of the image and size of the print may be restricted.

If you decide to print out images yourself, you will need to buy some photographic paper because ordinary ink-jet paper soaks up too much ink,

resulting in flat-looking photographs. By contrast, photographic paper is usually glossy, although matt and silk papers are also available. If you require a lot of prints, you will save money by printing your own, although not if you buy packs of twenty sheets of pre-cut paper measuring 4 x 6 in. (100 x 150 mm), which generally cost two-thirds more than the price of a repeat print made by a photographic shop, without allowing for wastage and ink use. If you buy A4 sized photographic paper and cut it to size yourself with a simple guillotine (available from stationery shops), however, the cost

Figure 162 The relatively inexpensive Canon Bubblejet 1450 colour printer.

will come down to maybe half the price of having a print made by a photographic shop and a quarter of the price of a repeat print. An intermediate step is to buy pre-scored A4 photographic paper, which is easily divided into separate sections after you have printed the whole sheet.

Note, however, that if you are interested in art photography, or want to create large prints to enter into competitions or exhibitions, you will require the best-quality paper and ink cartridges, in which case your first choice should be those recommended by the manufacturer of your printer. (I know that you can probably buy unbranded products for less money, but is your printer optimised for them?) Remember that different types of paper absorb different amounts of ink, and that the ink that is absorbed may be less visible, or even invisible. If the printer is set up to work with a particular type of paper, but is supplied with another, either more or less ink may therefore end up on the surface of the paper than there should have been, leading to either wet, and possibly, smudgy prints or to washed-out-looking photographs that lack the desired depth of colour. Although they may appear equally white and glossy, the acidity of photographic papers may also differ, consequently affecting a print's colour. If you are using a different paper from that recommended by the manufacturer of your printer and it is a sophisticated model, its software may allow you to make the appropriate changes, but a simpler printer will simply print the wrong shade. Be warned that the opacity, coverage rate, drying time and so on of printer inks similarly vary.

Even when you are using the most basic of printers and any combination of ink and paper, there is usually a great deal that you can do to improve your images.

VIEWING AND IMPROVING PICTURES BY TWEAKING

Sometimes your pictures will be disappointing, but if you have the appropriate computer software, you can improve them, sometimes quite drastically.

The successful photographing of landscapes in particular requires thought and care, and maybe experimentation, and yet you may still be disappointed with your prints. The

Figure 163 A scene that caught the photographer's eye, but whose composition was badly thought out. The red cars in the far distance provide a pleasing contrast to the green environment, but because a 28 mm lens was used, the cars appear so small as to be insignificant, rather than being picked out. Fortunately, however, the photograph was taken as a 6 megapixel shot in the RAW format, enabling the contrast to be adjusted and the image to be cropped and magnified, as shown in Figure 164. The work was done in Adobe Photoshop because the significantly cheaper, but only marginally less versatile, Adobe Photoshop Elements does not support RAW files, so that the colour-management information would have had to have been converted, resulting in a loss of quality.

Figure 164 The modified version of the photograph shown in Figure 163. The file remains large enough to be blown up to A4 size. Although the picture has been rescued, it is still not as good as it could have been.

fact is that when you saw the original landscape, your eye registered a far greater number of differences between light and shade than can be reproduced in a print, which may only record perhaps twenty tones, or shades, between black and white, and although a projected slide can may realise maybe a hundred, the human eye still registers far more.

First check to see whether the image that you have produced has the required brightness of colour and light-and-dark contrast when viewed on your computer's monitor screen. If not, you may be able to make the necessary adjustments using your computer software (see Chapter 13 page 226 onwards), as well as improve the

sharpness before specifying the size (in inches or centimetres, not bytes) of the print. It may then be that you print out the photograph, only to find that the image on the paper print does not match the one on the screen in terms of colour, contrast, or whatever.

Figure 165 This landscape is an example of art photography.

Figure 166 Shopping at the greengrocer's in the summertime. The bright colours attracted me to this scene, prompting me to pull a camera out of my pocket (always carry a camera around with you!) A clean print is essential if the colours are to look clear, however.

In this case, the problem may be one of perception, due to viewing the screen and the print in two different lights. Many beginners find that an image that seems bright and punchy on the monitor screen appears as an overcontrasted, burnt-out, 'soot-and-whitewash' disaster on paper. The

Figure 167 A good home-working environment for a digital photographer. Note that a flat, cathode-ray tube (CRT) monitor, which is better for graphics work, is in use rather than a flat panel (TFT) monitor. The halogen lamp provides light to work by when daylight is insufficient, while a blind can be pulled down over the window to reduce the amount of light entering from outside.

reason for this is probably because the image was viewed on screen in a room in which there was too great a contrast between the lit-up monitor and the ambient light from a window, and the solution is to turn up the contrast on the screen. Indeed, many computer-users like to work in front of a window, but while a sunny view may be pleasant, these conditions are, alas, unsuitable when working with images. And when it is dark and gloomy outside the window, you will probably select much less contrast when viewing the image on screen, which is admittedly more likely to result in a print that will satisfy you in normal viewing conditions, but will result in a loss of consistency. (Professional graphic designers work in constant artificial light, and not too bright a one either, never seeing the light of day when they are hard at work, and their results are consistently similar, whether they were produced at 2pm or 2am.)

If your workspace is illuminated with a fluorescent light, remember that its intensity will change dramatically after it has been switched on, also changing as the fluorescent tube ages, which is why professional graphics workers change theirs every few months, and six months at the most. Halogen lamps are far better when working with colour: not only do they provide a more constant light throughout their lifetime, but they are nearer to daylight in the colour spectrum. If you look at Figure 167, which shows a good working environment, you will see that the window has a blind, which can be

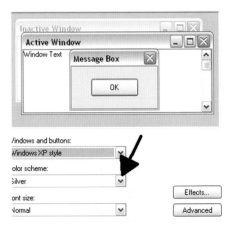

Figure 168 You can set the background colour for your computer's monitor screen by selecting one of the options – and preferably silver or grey – in the drop-down menu that has been highlighted here with an arrow.

Figure 169 The 'Adobe Gamma' icon in the Windows 'Control Panel'.

drawn to exclude sunlight, and that artificial light is provided by a table lamp fitted with a halogen bulb, which casts light on the keyboard, while the opaque shade ensures that sufficient light is diffused elsewhere (the ceiling light has not been switched on).

Remember, too, that a screen projects light and a print reflects light, which is another reason why an on-screen image may appear different to a paper image. These characteristics can, however, be turned to your advantage when working with an image that is intended to be viewed on screen rather than one you mean to print.

Another consideration is the background colour of your computer's monitor screen. If it is shocking pink,

lime green or another vivid colour, your eyes will become accustomed to bright colours, which will affect your decisions regarding the brightness and colour of the images that you view on screen, and will usually result in you turning up the screen's brilliance control too far. It's therefore better to select a neutral colour. If you are using Windows, you can change the screen's background colour as follows. If you go to 'Control Panel'/'Display' and choose the 'Appearance' tab, the window shown in Figure 168 will appear. Now select 'Color scheme', and then silver or grey from the drop-down menu. In other versions of Windows select a neutral scheme close to dove grey.

When choosing a monitor screen, be it to accompany a new computer or to

Figure 170 The Adobe Gamma window if the 'View Single Gamma Only' box is ticked.

upgrade your system, go for the largest-sized screen that you can comfortably accommodate and afford. Opt for a flat cathode-ray tube (CRT) screen rather than a flat panel (TFT) screen, however, because a TFT screen only gives you an accurate indication of the colour of an image when your head and eyes are in one particular position in relation to the screen – move to the left or right, or up or down, and the colour will appear different. By contrast, when using a CRT screen, you can change position quite a bit and still see the same picture.

Adobe Gamma

Regardless of the type of screen that you have, you can match it to your software and hardware using Adobe Gamma, a utility included in the Windows 'Control Panel' (see Figure 169) that enables you to calibrate and characterise your monitor and set the same characteristics (the 'colour

Figure 171 The Adobe Gamma window if the 'View Single Gamma Only' box is not ticked.

profile') for all your hardware such as printer and scanners. Although amateur working conditions can never quite reach professional standards, following these simple steps will greatly improve the colour match between your screen and your images.

If you open the utility, you will see one of the windows shown in figures 170 and 171. If you see the window shown in Figure 170, which contains one grey-coloured square, untick the 'View Single Gamma Only' box to reach the window shown in Figure 171, which contains red, green and blue boxes. (You can switch between these windows simply by ticking or unticking the 'View Single Gamma Only' box.)

To set the gamma correctly, which is vital to ensure that the content on the screen is reproduced accurately elsewhere, move the slider under each of the three coloured boxes until the plain area in the centre of each merges with the surrounding ruled box so that you cannot see where one starts and the other finishes. When all three boxes are as balanced as possible, tick

the 'View Single Gamma Only' box to switch back to the first window and repeat the procedure until the plain, grey, inner box resembles the outer, ruled box as closely as possible.

Because it is important to adjust the screen to obtain the correct colour match (which actually means contrast ratio) before adding an image to it, it is worth going back and forth from one screen to the other and fiddling with

Figure 172 The arrows highlight the Phosphors and ambient light temperature settings in Adobe Gamma.

the sliders until you have made the best possible matches. (And when you have found the correct settings, the 'Brightness and Contrast' bar above the coloured box or boxes will appear to be nearly black along its length; you should just be able to make out alternate blocks of solid black and ruled black.)

The vertical black arrow in Figure 172 shows the drop-down menu with which to select the ambient light's temperature. If you work by daylight, select 6500°K, for example. If you always work by fluorescent light, however, select a temperature to match your tube (if you don't know what that should be, maybe you should buy a new, cool white tube, for instance, and then select that option). Another possibility is to work by daylight during the day and by halogen light in the evening; because halogen lights usually (but check the bulb's packaging) simulate daylight, you can then leave the setting at 6500°K.

The horizontal black arrow in Figure 172 indicates another setting that you can check and fine-tune if necessary, namely the phosphors setting. Phosphors, the light-emitting substance with which the monitor screen is coated, differ in colour from one brand and model of screen to another, and will affect the colour that you see on the screen, perhaps also making it different to the colour that your printer will try to achieve unless you adjust the setting accordingly. To do this, you will first need to locate your monitor specification (the specification for the old Dell monitor screen pictured in Figure 167 stipulates P22 or equivalent, for instance).

Once you have finished adjusting the settings, don't forget to 'save' and 'apply' them before closing Adobe Gamma in the 'Control Panel' (and you may then have to reboot your computer to make the settings effective). This process is all part of colour-profiling, and you should also set your printer (using its software) and camera so that all of their settings match each other, and your computer, as closely as possible.

chapter 12

THE SLIDE SHOW

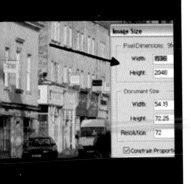

CREATING
A SLIDE SHOW

Slide shows are simply a sophisticated way of looking at a set of pictures without having to select, or search for, the pictures one by one. And digital photography enables you to stage slide shows either on your computer or on a big screen, using a projector.

Remember that in staging your slide show, you should be aiming to give a slick, professional performance, and that the pictures should appear on the screen one after the other, either automatically, perhaps one every five or so seconds – and you can specify the number of seconds – or in response to a single click of the mouse.

Many digicam manufacturers provide software for their products that includes a slide-show facility. The one in the Nikon's View system (which includes the Nikon Browser and Transfer shown in figures 175, 176 and 177) is explained below (see pages 216-219), while Sony provides MGI PhotoSuite; Ricoh, Photo Studio Lite; Contax/Kyocera, Pixela and so on. Most of these software programmes have a lot in common – after all, most digicam-users want to do the same sort of things with their images – and the following outline therefore applies to all such software.

Whatever software or system you are using, you will have to perform certain actions before you can produce a smooth-running show, with the images in the right order. First, you will need to place all of the images that you want to include in the slide show in a new folder, and because you will probably want to make a change or two to the slide-show images, it is best to make duplicates of the originals and

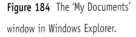

Figure 184 The 'My Documents' window in Windows Explorer.

then to transfer these copies to the new folder. It's important to make copies because if you make an irreversible mistake while manipulating a file, only that file will be spoiled, and you can always copy the original again. (If you are using a PC, all that you usually need to do to copy a file is to open it and, using the 'Save As' command, to save it under a new name and in a new location, but also see below for an alternative method.) However you duplicate them, the copies will be identical to the originals, which is more than can be said for 35 mm film copies of 35 mm slides in conventional photography, and the

process is a lot cheaper and quicker, too.

If you are using Windows Explorer (and the procedure in an image-handling application is usually much the same), you can create a new folder as follows. Open the 'My Documents' window (see Figure 184), click on 'File', 'New' and then select 'Folder'. Now look for the folder (which will be called 'New Folder') in the tree of folders or folder icons displayed in the window and rename it by right-clicking on the 'New Folder' name or icon, selecting 'Rename' and then typing in an appropriate name, such as 'Majorca holiday'.

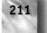

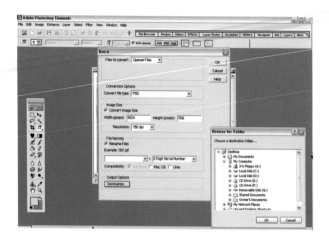

Figure 185 The 'Batch' window in Adobe Photoshop Elements.

To transfer the picture files to the folder, you could simply open the folder or folders that contain them in Explorer and then drag and drop the files into the new folder one by one, but it's safer to make copies of the files to place in the folder rather than transferring the originals in this way. You can do this in Explorer by holding down the 'CTRL' key and clicking on a file, then right-clicking and using the 'Copy' and 'Paste' functions, which is preferable to dragging and dropping a file or using the 'Move' function.

If you want to copy all of the files in a folder, using the 'Copy' command for the whole folder is much quicker than copying files individually. If you are working in Adobe Photoshop Elements or Adobe Photoshop itself, however, select the 'Batch' command from 'File' and then specify your preferred options. If you look at Figure 185, you will see the 'Batch' window in Adobe Photoshop Elements, with the 'Opened Files' (that is, files that you have previously opened one by one in Adobe Photoshop Elements) selected for conversion, but you could instead select a different option, such as a specific folder. First specify the required resolution (150 dpi is usually more than enough); then the image size in pixels (see below) to match the monitor screen on which you are either going to show the images or from

which you are going to project them; next, your preferred names or numbers (see below) for the files; last, the preferred file format, such as JPEG. Finally, click the 'OK' button in the top-right hand corner of the window.

If you find that you grind to a halt due to a software programme's limitations and there is a similar programme installed on your computer, try switching to that. If Windows Explorer won't copy folders, maybe Nikon View will, for example, while if Nikon View does not enable you to rename files, Explorer will. Using Windows, you can open several applications – perhaps Adobe Photoshop, Nikon View and Windows Explorer – and simply switch back and forth as you work your way through the list.

When it comes to listing files as mentioned above, note that the slide show will run in the same order as the files are organised in the folder. If you have numbered them from 1 to 20, however, remember that computer logic will list them in the following order: 1, 11, 12, 13, 14, 15, 16, 17, 18, 19, 2,

20! So try to follow computer logic when naming files and add some zeros so that the order runs: 01, 02, 03, 04, 05, 06, 07, 08, 09, 10, 11 and so on. Similarly, if the series extends past a hundred, use two zeros instead of one. If you have forgotten to include a picture file in the series, note that you do not need to rename all of the files, but should instead slot it into the series. If it needs to go between numbers 13 and 14, for instance, call it 13a and the computer will list it after 13 and before 14. And if you then find that you need to insert another file after that, call it 13b.

The next step is to resize the files, reducing the (compressed) file size to speed up the rate at which the computer's processor handles them, particularly if there are any particularly large files or a mixture of different sizes. If you ignore this step, you may find that there is an undesirable interval between the showing of each slide while large files are being processed. This is also one of the reasons why the pixel dimensions of each picture in the folder should be

the same as your monitor screen's setting. The size for a horizontal (landscape) picture – and a computer's monitor screen corresponds to this shape – is 800 x 600 pixels, so if the picture is vertical (portrait), you should enter the vertical dimension so that it matches your screen's setting (600 in this case) and the computer will then calculate and set the horizontal pixel dimension automatically. Before you do this, however, set the resolution to avoid these dimensions being changed if you alter the resolution after entering them.

Finally, save each file in the JPEG format. Now check and, if necessary,

Figure 186 The resizing dialogue box in Adobe Photoshop, which gives you the option of setting the image size and resolution. Set the resolution first, and then the image size (in pixels), as indicated by the arrow.

Figure 187 The arrow indicates the slider with which you can make a file smaller or larger in Adobe Photoshop.

adjust their final volumes by right-clicking on each file in the folder. One hundred KB is about the right size, and maybe a little more if the slide show is likely to be shown using a projector. If a file's size is more than 100 KB, go back to the 'Save' stage specify a lower 'Quality" setting and save it again. In Adobe Photoshop, for instance, open the 'JPEG Options' window (see Figure 187) and change the file size by dragging the slider to make it smaller (or, if necessary, larger), click 'OK' and then check the file size again. By selecting a file's quality in this way, you are choosing the degree at which it is compressed. Remember that if the files are too large, they can cause the computer to freeze, but if they are too small, their quality will be compromised.

PRESENTING A SLIDE SHOW ON A COMPUTER'S MONITOR SCREEN

All of the images that you want to include in your slide show should now have been reduced to the correct size and should appear in the right order within a single folder. Now let's look at the slide-show controls. First of all, however, you will need to start a slide show, and I shall use Nikon View to demonstrate how.

Figure 188 The opening window in Nikon Browser, showing the slide-show images as thumbnails. Click on 'Edit', indicated by the arrow, and select them all.

Figure 189 The colour of all the file mounts has changed from the grey shown in Figure 191 to blue, indicating that all the files have been selected. The arrow is highlighting the slide-show icon.

Having opened the application, navigate to the required folder in the tree on the left and click on it, after which the thumbnail images will appear. Then click on 'Edit' (see Figure 188), select 'All', and the file mounts will change colour to indicate that they have been selected (see Figure 189). Now click on the slide-show command, which appears as an icon in the tool bar (see Figure 189) or in a drop-down menu under 'Tools'.

When the slide show starts, the 'Slideshow Properties', or slide-show control, box appears. This control box can be dragged around the screen, and can be minimised by clicking on the

little arrows in the top left-hand corner so that only the top portion is visible (you may find it convenient to do this and then to drag the minimised box to the bottom of the screen so that it is accessible, but not a distraction). If you want to use the automatic function, you can also make the control box disappear completely by using the tab key on your keyboard to toggle it off (and on again if you wish).

The slide-show control box is shown in detail in Figure 191. You can click on the 'Back' and 'Forward' buttons to return to a previous slide or advance to the next one, while clicking on the red button will stop the show. The green figures in the bar at the top tell you

Figure 190 The 'Slideshow Properties', or slide-show control, box appears when the slide show is started.

Figure 191 The slide-show control box, showing the available options. The arrow indicates the 'move to next slide' command.

the slide that is being viewed (which fills the screen) and the number of slides in the show (and the numbers in Figure 191 indicate that the first of fifteen slides is being shown), along with the time interval between slide changes – 4 in this instance. You can vary this time interval, and also make other adjustments, by accessing the menus below the row of control buttons, and can select an automatic setting if you wish. If several people are watching the slide show, specifying an automatic slide change every seven or eight seconds is usually about the right time interval, but the advantage of controlling the slide change manually is that you can quickly skip past any slides that don't interest your audience.

PROJECTING A
SLIDE SHOW

The procedure for projecting a slide show is exactly the same as for presenting it on a computer's monitor screen, the only difference being that the computer is connected to a projector and must therefore be set up accordingly. In addition your computer must have an appropriate output socket. An S-Video, or a Video Out is usually ok, while and A/V port may not be sufficient.

Digital projectors are basically the same projectors that are used in home cinema to project images from a DVD onto a wall or screen. In digital photography, however, a computer, rather than a DVD player, is used to control the image files and pass them to the projector. The procedure is the same as if you were staging a slide show on a computer's monitor screen, just with the video output connected to a projector. Note that not all

Figure 192 The Sanyo Pro-Ex SW20A digital projector is typical of several models of similar capability and price made by half-a-dozen manufacturers.

Figure 193 This image demonstrates how a picture can be distorted when a projector has to be tilted upwards to project the image onto a screen.

Figure 194 Most digital projectors enable you to press a button to correct the type of distortion shown in Figure 185, and here is the same image following such 'keystone correction', as it is called.

Figure 195 The 'Display' window in Windows ME which is accessed from 'Control Panel'/ 'Display'/ 'Settings' /'Advanced', showing four different potential outputs, only one of which – 'Monitor' – has been enabled here. It is necessary to enable 'TV' to provide an output signal for the projector.

computers have a video output socket, so consult the machine's specification. Projectors used to be extremely expensive, but are now merely expensive, and the digicam experience has shown that when the price of a product starts to come down, the quantities sold shoot up and the benefits of mass production and marketing kick in, causing the price to

to tumble further. Indeed, the cost of the cheapest projector has halved in the space of a couple of years, and I have little doubt that it will soon halve again.

Even the lowest-priced modern digital projectors can easily project a bright and appealing picture that is 6 ft (1.8 m) in size without you having to black

out the room completely. And if you have been used to projecting 35 mm slides, they will seem like the 'magic-lantern' pictures of the old days in comparison to these bright digital images.

You will first need to connect the computer to the projector, perhaps with two cables, one for images and one for remote control (that is, if you wish to use the hand-held remote-control device that is normally provided with projectors). Note that you may need to turn on the projector before switching on the computer, otherwise the computer may not recognise it. You must also enable the computer's TV, or video-out, function (which you can leave enabled when the projector is not being used).

When you have successfully connected the computer to the projector, open the slide-show software in the computer and set the slide show in motion as explained above. The images will now be shown one after the other, both on the computer screen and, via the projector, on a larger screen, either at the automatic intervals that you have set and enabled or in response to a click of your mouse or remote-control device on the slide-show controls. If you are giving a lecture from a podium, this means that you can set a laptop on the podium, face the audience and see exactly what they are viewing on the big screen on your monitor screen as you control the slide changes with your mouse or touch panel.

SOME FINAL TIPS FOR SLIDE SHOWS

Whatever type of slide show you are presenting, note that adding a title slide or two will make it look more professional. Title slides are quick and easy to create in an image-handling software programme (see pages 192 to 195), using suitable background slides with large, vacant areas.

My final piece of advice is to keep slide shows short – ten minutes should be the maximum length for most. Remember that it's better to leave your audience begging for more rather than yawning.

Figure 196 A title slide can close a slide show, as well as open it.

IMPROVING THE IMAGE IN THE COMPUTER WITH SOFTWARE

IMPROVING THE
IMAGE IN THE COMPUTER
WITH SOFTWARE

The extent to which you can manipulate images using computer software is enormous, so much so that I cannot cover everything in this book, just explain a few of the regular manipulation routines and give you a few ideas and suggestions.

Adobe Photoshop is the industry-standard image-manipulation programme for graphic designers, and is therefore the most expensive, but there are many other image-handling programmes available, too. Look out for free evaluation, trial or demonstration copies of such software in photographic magazines, and if you like one, you can normally download the full version for a price.

Be warned that although the better-quality software offers amazing possibilities, the learning curve is very long, so that you cannot just install the software and immediately start producing masterpieces. Nevertheless, if you have such a programme, you can easily improve your pictures by cropping them, varying the brightness or contrast, adjusting the colour and tilting the image, and going further when you are ready and have learnt more.

CROPPING AN IMAGE

Figure 197 MGI PhotoSuite's opening window. The arrow points to the 'Get Photos' option.

This demonstration of how to crop (or trim) an image is being carried out in MGI PhotoSuite. Although many applications use the words 'crop' and 'trim' to express the same concept, MGI PhotoSuite uses 'crop' to mean adjusting the file size, pixel count or print size without the picture being affected, while 'trim' means discarding parts of the picture.

Figure 199 The left-hand arrow highlights the scissors icon, while the right-hand arrow indicates the top right-hand corner of the rectangle that has been created after clicking on that icon.

Figure 198 The file containing the picture to be cropped (or trimmed) has been selected and opened.

Figure 200 The rectangle encloses the part of the picture that will be retained after the 'Trim' function has been selected.

Open the application, click on the 'Get Photos' option, navigate your way to the file that you want to crop and then open it. Select the scissors icon with your mouse, and then drag a rectangle over the image to define the cropped picture's limits (see Figure 199). When you are happy with the trimmed image, select the 'Image' drop-down menu and then 'Trim' (see Figure 200). Click 'Save' to save the trimmed image or 'Save as' to create a new file and preserve the original one.

Figure 201 The cropped picture.

VARYING THE BRIGHTNESS, CONTRAST, HUE AND SATURATION AND SHARPENING AN IMAGE

Now let's try varying the brightness or contrast of a picture using different software, in this case Ricoh PhotoStudio Lite.

Figure 202 Ricoh PhotoStudio Lite's opening window.

When you open the application, the window shown in Figure 202 appears. Select the 'Open Folder' icon on the far left, navigate to your preferred file and then open it. Figure 203 shows the open picture file. Arrow A is pointing at the 'Brightness and Contrast' icon; arrow B, at the 'Hue and Saturation' icon; and arrow C, at the 'Sharpen' icon. To adjust any of these aspects of the picture, click on the appropriate icon, drag the slider back and forth until you are happy with the result and then click on 'OK' (see figures 204, 205 and 206).

Sharpening is a function offered by

Figure 203 The picture file has been opened. Arrow A indicates the brightness and contrast icon; arrow B, the hue and saturation icon; and arrow C, the sharpening icon.

most good image-handling programmes. and yes, it does sharpen a picture, but do not think that it will transform an

old, out-of-focus picture completely because there are limits to what it can do. It works like this. At the blurred edge between a dark zone and a light zone in a photograph, it is as though dark and light pixels have been mixed up rather than all of the pixels being either dark or light. The sharpening function identifies such areas and removes the dark pixels, leaving nothing behind, so that if you sharpen the image too much, you will end up with a white halo around the previously dark areas. If this happens, the picture will look very odd, but thankfully the function enables you to undo the undesirable result and reduce the effect. An image should always be sharpened as the last operation in every image-handling sequence. Photoshop allows the degree of sharpening to be really closely monitored and controlled.

Figure 205 The 'Hue and Saturation' window.

Figure 206 The 'Sharpen' window. Always sharpen an image last.

ADJUSTING THE COLOUR

If a picture's colour seems wrong, and you cannot correct it by adjusting the hue and saturation, try doing the following, but work on a copy of the original picture file because it is all too easy to ruin a nearly good image.

Open the image in Adobe Photoshop and select 'Image', 'Adjustments' and then 'Variations . . .' (see Figure 207). (If you are using Adobe Photoshop Elements, select 'Enhance'/'Variations'.)

You will now see a window full of colour variations (Figure 208). Click on a suitable one and it will become the current mode, after which a new set of variations will appear based on this

Figure 208 The variations shown in the 'Variations' window demonstrate the effect of adding more of each of six colours – green, yellow, cyan, red, blue and magenta – to the image.

Figure 207 In Adobe Photoshop 'Image'/ 'Adjustments'/' Variations . . .' were selected.

selection. If you are happy with the result, you can then save the image and work on it further.

TILTING THE IMAGE

Straightening the horizon and making a vertical appear really vertical are both aspects of tilting, which is useful when working with pictures that have been shot at the wrong angle, such as that shown in Figure 209.

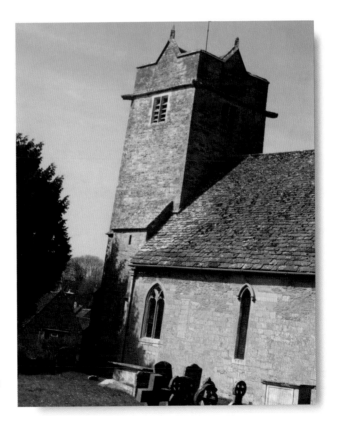

Figure 209 It will certainly be necessary to correct the verticals in this image.

If you are working in Adobe Photoshop, open the picture file that you want to correct. Now select 'View', 'Show' and then 'Grid' (see Figure 210) to superimpose lines over the image to act as a guide when making your corrections. Next, select 'Image', 'Rotate Canvas' and 'Arbitrary' (see Figure 211) to bring up the 'Rotate Canvas' window. The arrow in Figure 212 indicates where you should

Figure 210 Add a grid to an image by selecting 'View', 'Show' and then 'Grid'

Figure 211 The next step is to select 'Image', 'Rotate Canvas' and 'Arbitrary'.

Figure 212 The arrow indicates where you should enter a figure in the 'Rotate Canvas' window in order to correct the angle.

Figure 213 The picture has been successfully rotated.

enter a figure (take a guess to start with) in order to correct the angle. Then select either 'CW' (which stands for clockwise) or 'CCW' (counterclockwise, or anticlockwise), click 'OK' and see what happens. Note that you will probably have to experiment a little before you get the angle right (see Figure 213).

Finally, crop the image by activating the crop tool in the floating vertical tool bar to the right of the image. Drag a rectangle on the image to the desired point and click to trim (or crop). Finally, remove the grid by reversing the procedure by which you superimposed it over the image.

Figure 214 The final result.

chapter 14

IMPROVING THE IMAGE IN THE VIEWFINDER AND CAMERA

SEARCH FOR
A NEW VIEWPOINT

Rather than worrying about how to improve your images using software, you'd be well advised to try to take better pictures in the first place! This chapter will tell you how to improve your skills as a photographer.

If you are photographing a hackneyed subject, such as a seaside harbour, look for an unusual viewpoint before taking a shot (see Figure 215).

Figure 215 Reflections. This image started off as a conventional picture of a rigged yacht, but was later turned upside down and the boat cropped away so that only the reflection was left. The colour was modified a bit, too.

PHOTOGRAPHING
PEOPLE AND ANIMALS

If you are snapping a person, the face is usually the most important feature to capture, so that moving closer to him or her, or using the zoom, will result in the best picture.

If you are photographing a view, remember that because they add life to an image, including people in the picture will generally improve the shot. Note that the people should be positioned correctly and in proportion to their surroundings.

Figure 216 A view photographed at a stately home on an open day. The aim in taking this shot was to capture a view of the garden pavilion, and the inclusion of visitors in the picture adds both a sense of scale and life, although they are not so prominent as to make the image a picture of family members on their day out (in which case they would have filled the frame).

Animals also make good photographic subjects: consider wildlife photography, zoos and shows.

Figure 217 Animals are good subjects for pictures, especially when they are photographed from a favourable angle (and remember that front views are always more attractive than rear views!)

THE RULES
OF COMPOSITION

Certain rules of composition appear to have been universally agreed by artists over many hundreds of years, and the next time you visit an art gallery, bear them in mind – you may be surprised to see how often they apply to the images in front of you. Remembering them when taking photographs will also help you to create pictures that are good enough to hang on the wall or to use for your own calendars and greetings cards.

Rule 1: Portrait-shaped pictures are for active subjects

Portrait-shaped (vertical) pictures are the best choice for active, vibrant subjects like people and sporting action.

Figure 218 The balloon seller. A successful example of a portrait-shaped shot.

Rule 2: Landscape-shaped pictures are for views

Landscape-shaped (horizontal) pictures are best used for landscapes, seascapes and photographs conveying a peaceful, restful atmosphere.

Figure 219 Contemplation. An evocative landscape-shaped photograph.

Figure 220 An anhinga drying its wings. Not only does the star shape have no relevance to the subject matter, but it has resulted in interesting parts of the photograph being cropped away, thereby demonstrating that you should think hard before turning an image into a fancy shape.

Rule 3: Avoid square pictures

Square photographs look boring, so if you scan old 2¼ in.-square slides or trim a conventional 35 mm picture, try not to end up with a square.

Rule 4: Use unusual shapes sparingly

Although transforming images into fancy shapes like stars can be fun, the subject should be appropriate and the effect should be used sparingly, otherwise the final result may look unattractive or silly.

Rule 5: 'Thirds' are points of interest

'Thirds', imaginary lines one-third of the way into a picture from either side or the top or bottom, are a picture's areas of interest. The points at which the horizontal and vertical thirds intersect are the ideal points at which to position the main features of interest in a view. Thirds are also good lines for horizons. (Try to avoid dividing the picture across the middle in either direction, however.)

Figure 221 Red lines have been added approximately one-third of the way in from the top, bottom, left-hand and right-hand edges to indicate this picture's 'thirds'. Note how points of interest lie on, or very near, these lines, such as the umbrellas and principal figures.

Rule 6: Strong lines should draw the eye into a picture

Strong lines that extend across a photograph in any direction should draw the viewer's eye into the picture, not lead it out of the image.

Figure 222 In this photograph, the edges of the drive draw the viewer's eye towards the stately home's front door – they 'lead you into the picture'.

Figure 223 La Gomera, in the Canaries. The nearness of the red flowers emphasises the distance of the far-off mountains.

Rule 7: Position coloured and moving objects carefully

If you have any choice about positioning strong-coloured objects, remember that placing a red one in the foreground and a blue one in the distance will look the most natural. Note, too, that positioning a red object in the distance tends to give the illusion of bringing the distant parts of the image nearer. And if anything in the frame is moving, such as a boat,

Figure 224 This tugboat was photographed as it moved into the frame at Bristol docks.

vehicle or people, compose the picture so that it is travelling into the picture (usually from the left), not out of it, which again looks more natural and holds the eye within the frame.

Rule 8: Alternate colours and subject matter in slides shows

Although a picture does not have to include masses of colour in order to make an impact, when presenting a series of shots in a slide show, remember that alternating images that contain muted colours, on the one hand, and vivid hues, on the other, as well as restful and active subject matter, will keep your audience interested and awake.

Rule 9: Study your camera's instruction book and get to know your gear

All of the more sophisticated digicams, which means most of the latest generation of models, offer the photographer many possibilities. Spending an evening or two reading your camera's instruction book, both as soon as you have bought your digicam and later, when you have become more familiar with it, will pay dividends in terms of producing better pictures.

Figure 225 Muted colours prevail in this photograph of mowing for silage.

Figure 226 Flower markets, like this one in Funchal, Madeira, are always good places in which to photograph bright colours. Not only do the muted tones of their clothes provide an effective contrast to the vivid colours of the flowers and peasant costumes, but the two customers' presence makes it clear that the scene was not staged.

Rule 10: There are no rules!

It may sound like a contradiction to say that there are no rules at the end of a long list of rules, but remember that every rule is made to be broken, just not too often.

THE IMPORTANCE
OF LIGHTING

Photography was called 'painting with light' at a very early stage in its history, a description that still holds true today.

It's important to understand that the same subject can look boring in one light, but interesting in another. When

Figure 227 A view from a window photographed early one summer's morning. Note the long shadows that have fallen on the field in the middle distance, which add interest to what would otherwise have been a rather boring area of grass. The aerial perspective means that the far distance looks really far away. The shadow on the lawn in the foreground makes that part of the picture dark and uninteresting, however.

Figure 228 The same view as that shown in Figure 227, but photographed a few hours later, when the sun was a little higher in the sky. Although the long shadows in the middle distance are not as interesting as they appeared in Figure 227, this is more than made up for by the play of light and shadow on the lawn in the foreground. Had this scene been photographed a couple of hours later, there would have been no shadows at all, and two-thirds of the picture would have been less interesting as a result.

photographing many outdoor scenes, especially landscapes, for example, early morning and late-afternoon or evening light will result in a much more interesting picture than if it was taken in the flat light of midday. (Photographers have long known this, but the problem with film photography was that pictures turned out unnaturally red when taken at such times, and adjusting the colour was not easy. With digital photography, it is a piece of cake! If a photograph appears too red, open its file in an image-manipulation software programme, select 'Variations' (see Chapter 13, page

Figure 229 Using fill-in flash has made all the difference to this shot, in which the lighting, coming from behind the statue, was totally wrong.

Figure 230 The picture shown in Figure 229 has been further improved by the removal of the tree trunk behind the statue's head and more touching up in Adobe Photoshop.

231) and reduce the picture's red content.)

If you cannot avoid photographing a subject at noon, you will have to work harder to make your pictures interesting, perhaps by including an eye-catching feature in the foreground

and either using fill-in flash to brighten it up or 'burning in' (using Adobe Photoshop and the 'Layers' function, for instance).

RUNNING OUT
OF SPACE?

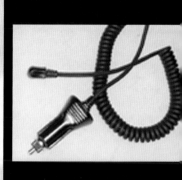

RUNNING
OUT OF SPACE

One of the few disadvantages of digital images is that they take up a lot of space on a computer. And after a few months of profligate shooting, your store of images may have a combined size of a few gigabytes, so that it won't be long before your hard disc becomes full.

In terms of freeing up space on your hard disc, your only options until recently were to reduce the size of the picture files (which is undesirable), to copy them to a Zip disc or burn them onto a CD before deleting them from your hard disc, or else to store them on an external hard drive. Today's storage alternatives do not even need to be connected to a computer, however, just directly to the memory card. One such is the Image Tank and similar devices.

Figure 231 The Image Tank. with its associated connecting and re-charging cables.

THE IMAGE
TANK

When the Image Tank was first launched, it cost about the same as a 1 GB memory card, but had a capacity of 20, 30 or 40 GB. They can be expected to get cheaper. Small enough to fit into a pocket, this device is battery powered, the battery being recharged either from a car's cigarette-lighter socket or, via an adaptor, from a mains supply of anywhere between 100 and 240 volts. It accepts almost any memory card, and once the images have been transferred to it, you can reuse the card immediately, which means that you don't have to take an extra memory card with you if you are off to shoot a lot of images. Once you have returned home, if you wish, you can then transfer the images stored in the Image Tank to your computer by means of a USB cable.

A FINAL
MESSAGE

Figure 232 Looking down over Funchal, Madeira, from the top of the funicular among the clouds.

Enjoy your photography. Goodbye from the author..

GLOSSARY

AE Automatic exposure the camera's fixed exposure setting.

AF Auto-focus – the camera automatically focuses on the subject of the picture.

aperture The effective size of the lens opening - expressed as the f number.

aperture priority The camera is set so that aperture is manually selected, leaving the AE to fit the shutter speed to suit it.

array The light-sensitive set of pixels which replace the film in a digicam (see CCD).

BMP or bitmap An image file format suitable for large files.

bracket Setting the camera for multiple exposures in succession, each bearing a different relationship to the original.

buffer The camera's temporary store of electronic information.

burst mode Taking several pictures in rapid succession.

CCD Charge-Coupled Device - the light sensitive cells that receive the image.

compression Reducing the size of a file by discarding some details.

contrast The difference between the blackest black and the brightest white.

crop Trimming or cutting off part of the image; also reducing the file size.

CYMK Cyan, Yellow, Magenta and Black colours which can be mixed to make any conceivable colour.

dock A device for receiving the camera, and providing easy connection for battery recharging and/or printing.

exposure The combination of time and aperture used in a particular picture.

f number The stop number or aperture expressed as focal length divided by effective lens opening diameter..

fill-in flash Flash exposure calculated so as to supplement other light sources and not replace them.

film speed The ISO rating or sensitivity rating of the film.

firewire Also called IE1394 port. A rapid data transfer connection between computers to peripheral devices.

fish-eye An extremely wide angle lens.

flashpath adapter A device for downloading a memory card without a cable connection using the A-drive (floppy disc) of the pc.

flat-screen A CRT monitor with minimal curvature on the front face (best for computer image work).

fps Frames-per-second, or the number of

pictures taken per second - a phrase borrowed from cine-cameras.

frame An individual picture.

gamma The contrast ratio setting of a computer screen.

GIF Graphics Interchange Format. An image file format.

hot shoe A bracket to fix a flash-gun on a camera etc, and with contacts to the camera electronic system.

hue One of three parameters (along with lightness and saturation) which, if defined, will specify a particular colour.

interchangeable lens A lens which can be disconnected and replaced by another.

ISO International Standards Organisation - which sets the values for ISO sensitivity ratings of films.

JPEG/jpg Joint Photographic Experts Group. A file format used widely in digital photography where a degree of compression is involved.

landscape A picture which is wider than it is high (see portrait).

LCD Liquid Crystal Display, usually relating to the viewing screen on digital cameras.

lens The assembly of glass elements on a camera which focuses the light into an image.

long (as in lenses) Of long focal length, a telephoto lens which magnifies objects.

macro Ultra close-up.

manual Setting both aperture and shutter yourself and switching off the automatic exposure.

matrix metering AE control involving taking light readings at many places on the image..

mega pixel Slang term for for multi-million pixels.

memory card The digital storage device which stores images in a digital camera.

menu A list of options and commands displayed on a camera's LCD screen.

movie mode Similar to burst mode, simulating a movie camera.

multiplier factor Correction factor for focal length when using a film camera lens on a digicam.

pixel A single dot of an image.

pixelation Over-enlargement to the point where the individual pixels are actually seen as squares of colour.

portrait A picture that is longer than it is wide.

posterisation Turning a picture into poster colours with a limited number of shades.

projector A slide projector or cine film projector, but here used to mean showing the images straight from a computer .

RAW An image file format ideal for archival work.

resolution The sharpness of a picture.

RGB Similar to CYMK, but using the red, green and blue elements to make up any desired shade.

saturation The amount of neutral or grey tones in an image as well as RGB or CMYK.

scanner A device for converting an optical image (e. g. a print or a colour slide) into a digital file.

sensitivity The same as film speed. The higher the sensitivity, the less light is needed to record a satisfactory image, and vice versa.

sharpen Make the image look less blurred. Improve the apparent focussing.

shutter priority Setting the camera shutter speed manually, and allowing the AE to fix the aperture.

slideshow A series of images shown one after the other on some kind of screen.

SLR Single Lens Reflex, the lens which provides the image on the film or CCD also provides the image in the viewfinder.

spot meter AE system taking light readings from a single place.

tele (telephoto) Same as long or zoom lens.

TFT A flat panel monitor – not to be confused with a flat screen. A flat panel monitor may be only a couple of inches (5 cm) thick.

thumbnail A postage stamp-sized image.

TIFF/tif Tagged Image File Format suitable for large, detailed images.

trim To cut or crop a section off a picture; sometimes refers to reducing the file size.

viewfinder The camera's optical device which shows the field of view of the lens.

white balance 'White light' is actually a different colour at dawn or dusk, or from a lamp. The balance control makes adjustments for this.

wide angle A lens seeing a wider angle than the human eye. The opposite of telephoto.

VGA Video Graphics Array, the standard definition for colour screen displays.

zoom ratio The longest (telephoto) focal length divided by the shortest-wide angle focal length = zoom ratio.

INDEX

CREDITS AND ACKNOWLEDGEMENTS

My most grateful thanks go to my dear Joyce, for her forbearance and patience when I disappeared for long hours to the keyboard/studio/digital darkroom while composing this book. Her support in this, as in so much else in my life, makes it all possible.

My thanks to the many manufacturers who replied to my enquiries about their products. Although a number of cameras, printers and scanners are mentioned by name, I received no special help from any manufacturers and any opinions expressed are my own.

Some of the printer and camera illustrations are provided courtesy of the manufacturers' press offices, and others are my photographs of my own equipment. Other illustrations are from my own collection or are screen shots from my computer.

Any mistake, imperfection or fault anywhere in the book is certainly down to me, but then as my kids used to tell me when showing me their end-of-term reports, 'no one is perfect'.

Microsoft screenshots reprinted by permission from Microsoft Corporation.
Adobe product screenshots reprinted with permission from Adobe Systems Incorporated.

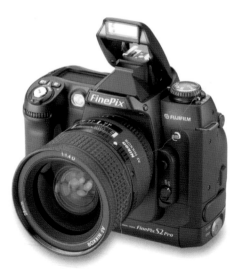